FROM THE CREATOR & ILLUSTRATOR OF EV
HIP HOP
COLORING BOOK

MARK 563

There are two things in my life that have remained a constant – drawing and hip hop. I discovered and fell in love with hip hop in the mid 1980s, and had been drawing since much earlier. While my hip hop career was limited to that of a part-time club and radio DJ, my drawing and art have always been my main focus. To this day, I may play the occasional hip hop gig, but my day-to-day finds me tattooing and illustrating. The two are very much intertwined though, as hip hop most definitely influences the majority of my artwork.

This book is a celebration of hip hop culture and the artists who have inspired me throughout my life. These illustrations are my personal artistic interpretations of some of hip hop's most important figures, and I would like to thank all the artists that have inspired my work.

I have done all I can to reach out to all the artists featured within this book, and have received overwhelmingly positive feedback from most. If anyone has not been reached, and wishes to be excluded from the book, please contact me and we will arrange that for future print runs.

Mark 563

runtheline@gmail.com
www.facebook.com/mark563art
@mark563

Hip Hop Coloring Book
Mark 563
ISBN 978-91-85639-83-0
© 2016 Dokument Press & Mark 563
Printed in Poland
First printing

DOKUMENT
PRESS

Box 773, 120 02 Årsta, Sweden
www.dokument.org
info@dokument.org
@dokumentpress

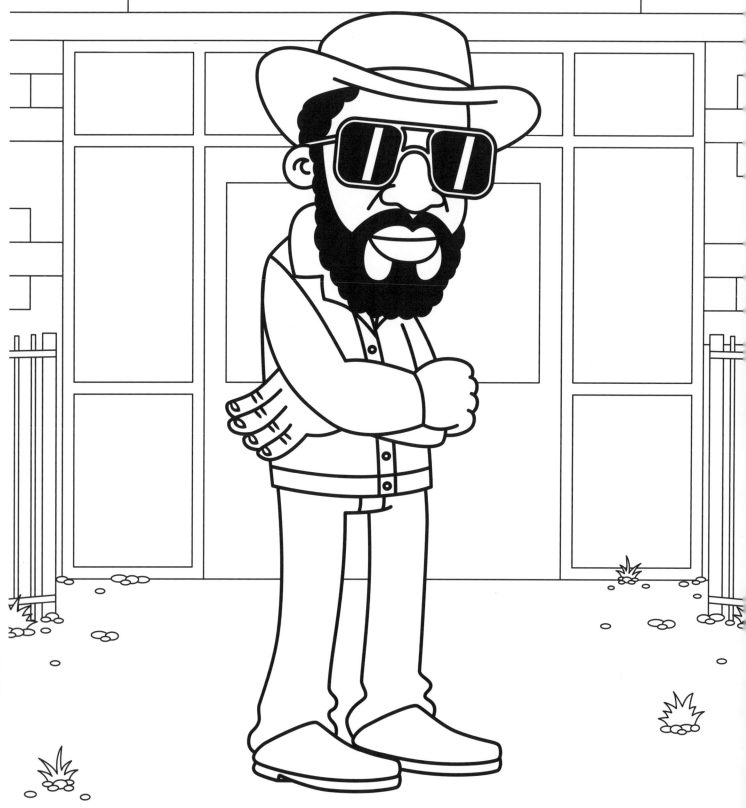

1520 SEDGWICK AVE.

DJ KOOL HERC

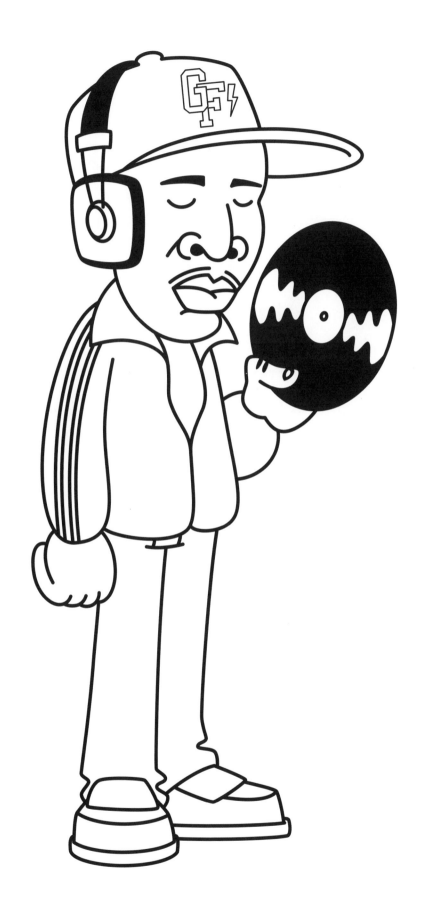

GRANDMASTER FLASH

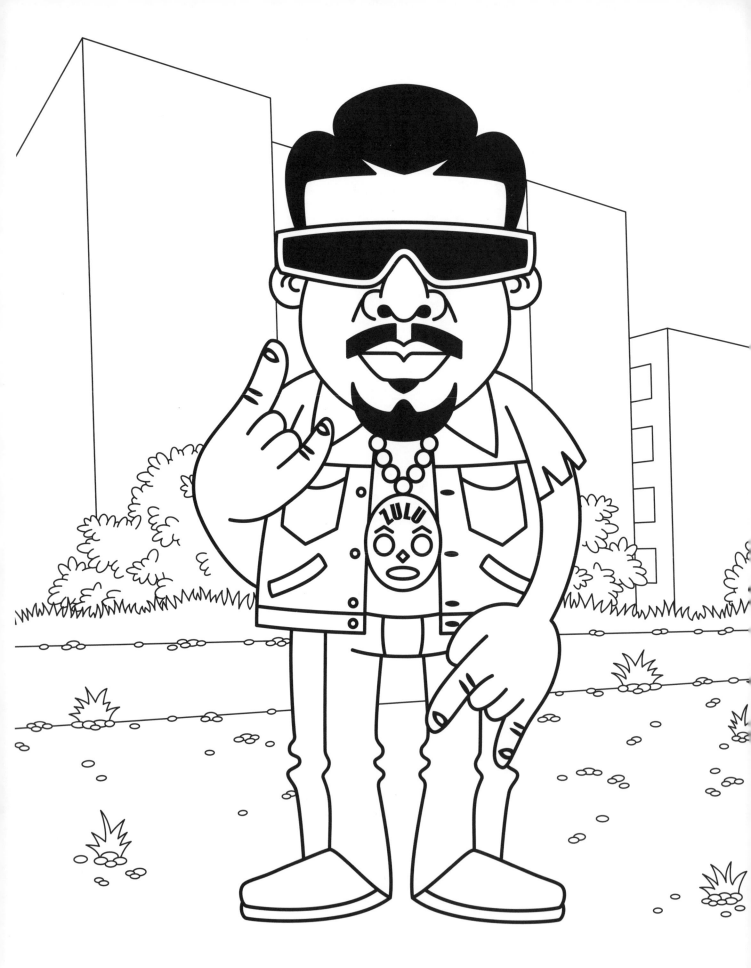

AFRIKA BAMBAATAA

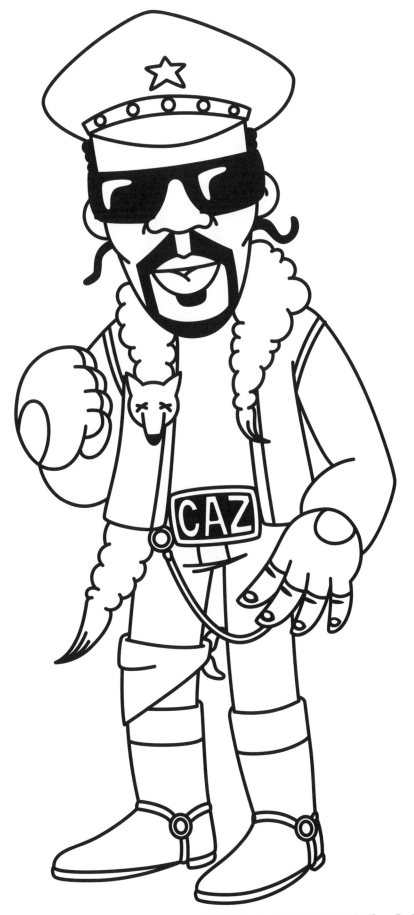

GRANDMASTER CAZ
THE COLD CRUSH BROTHERS

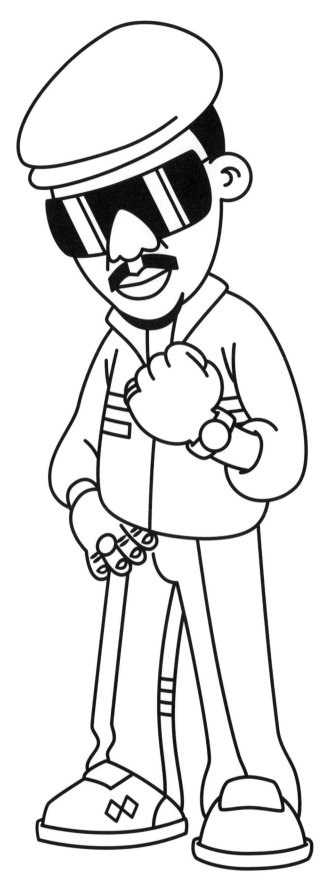

KOOL MOE DEE
THE TREACHEROUS THREE

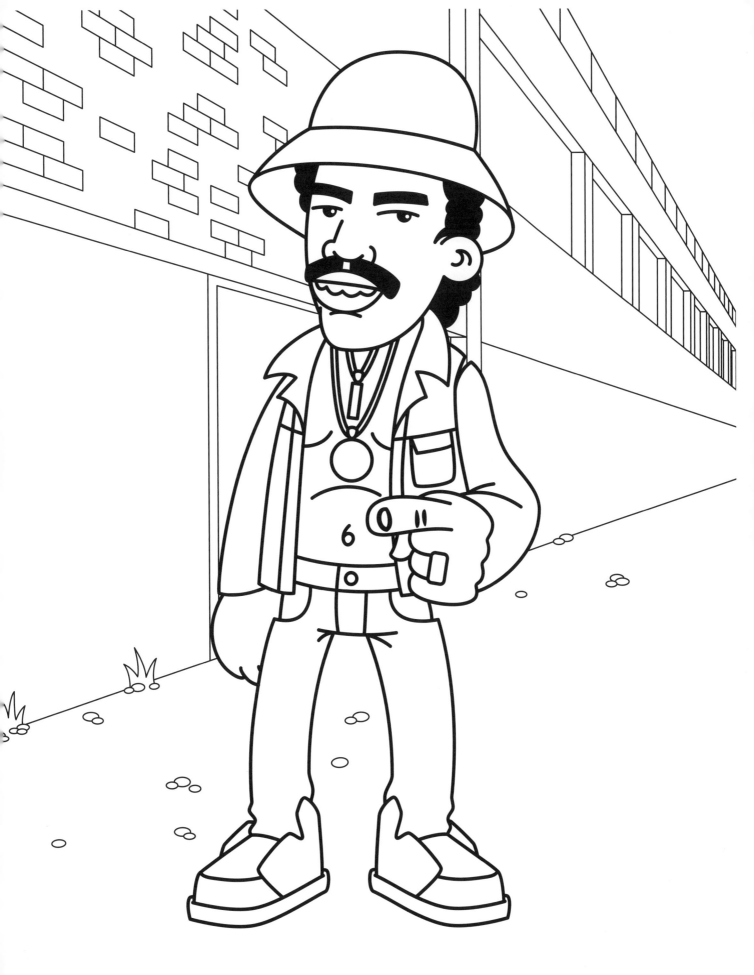

KURTIS BLOW

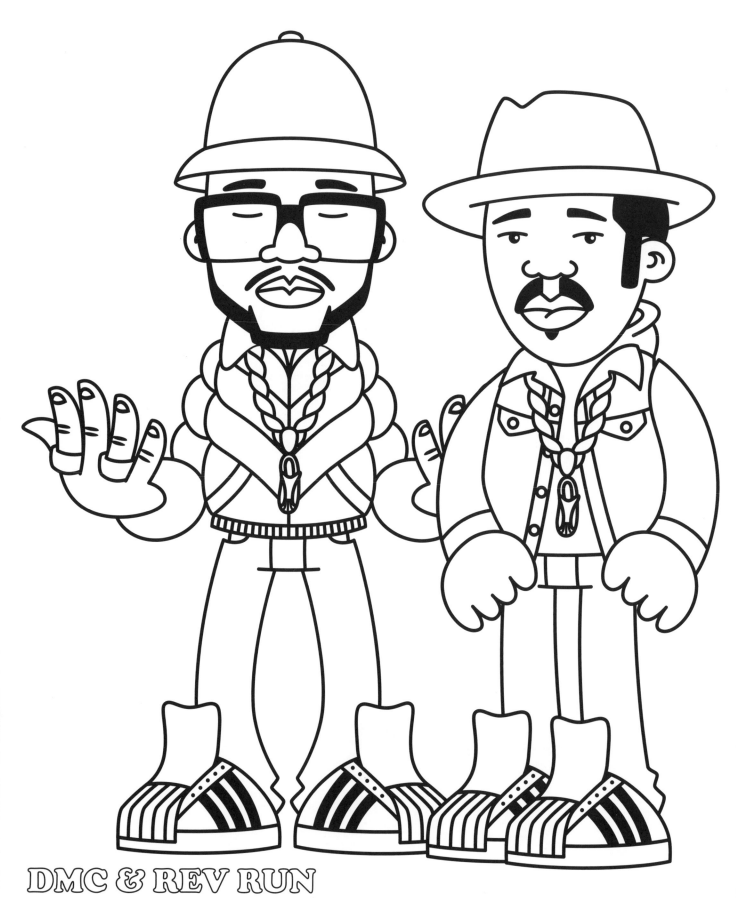

DMC & REV RUN
RUN DMC

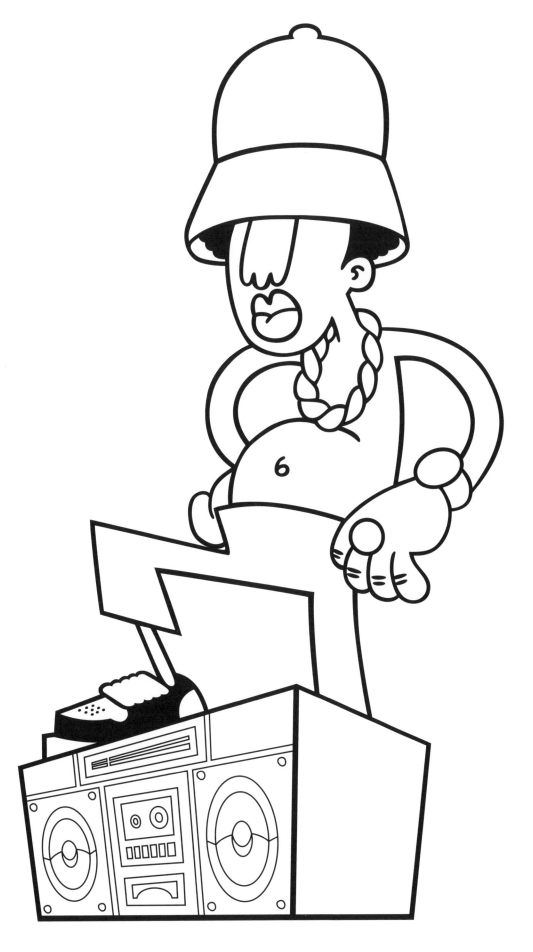

LL COOL J

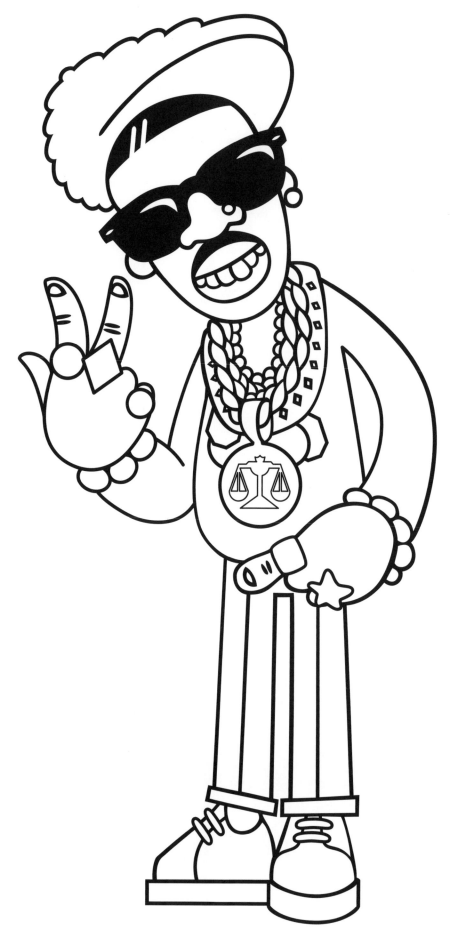

SLICK RICK

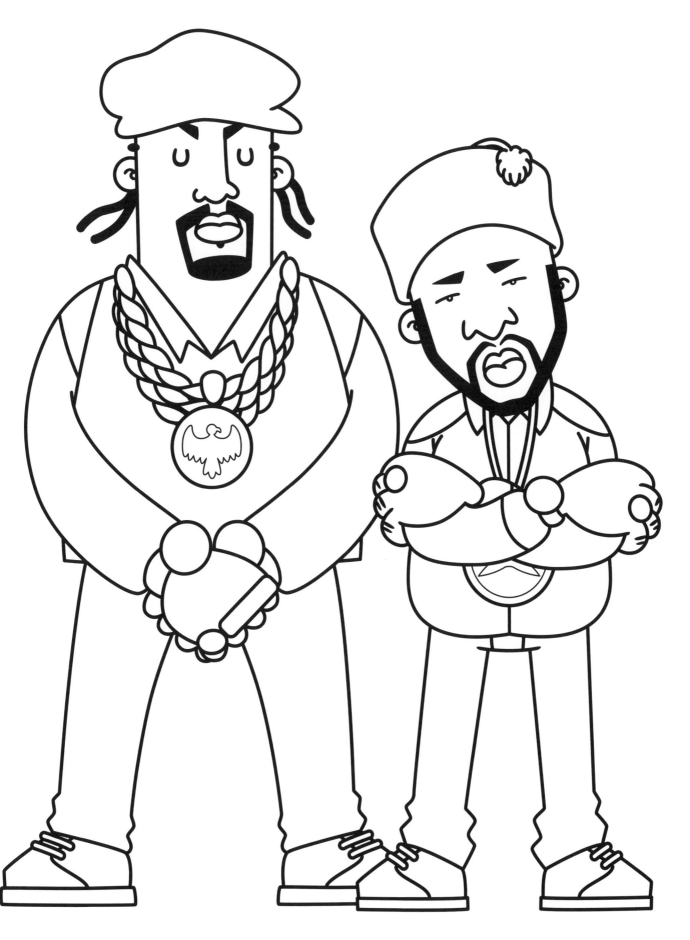

ERIC B & RAKIM

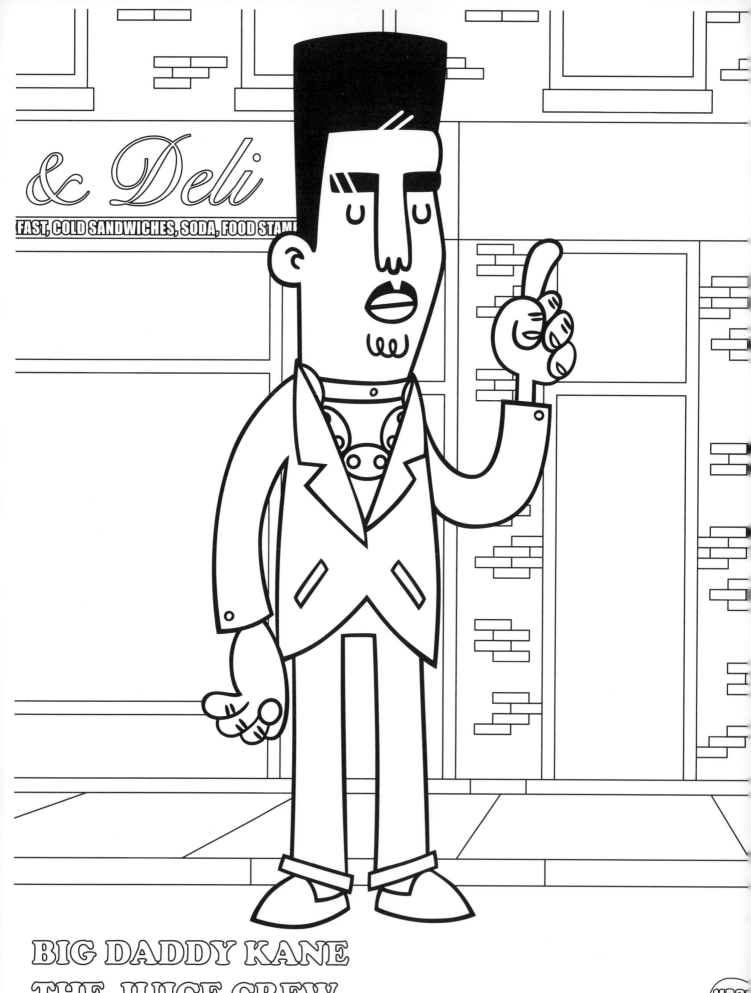

BIG DADDY KANE
THE JUICE CREW

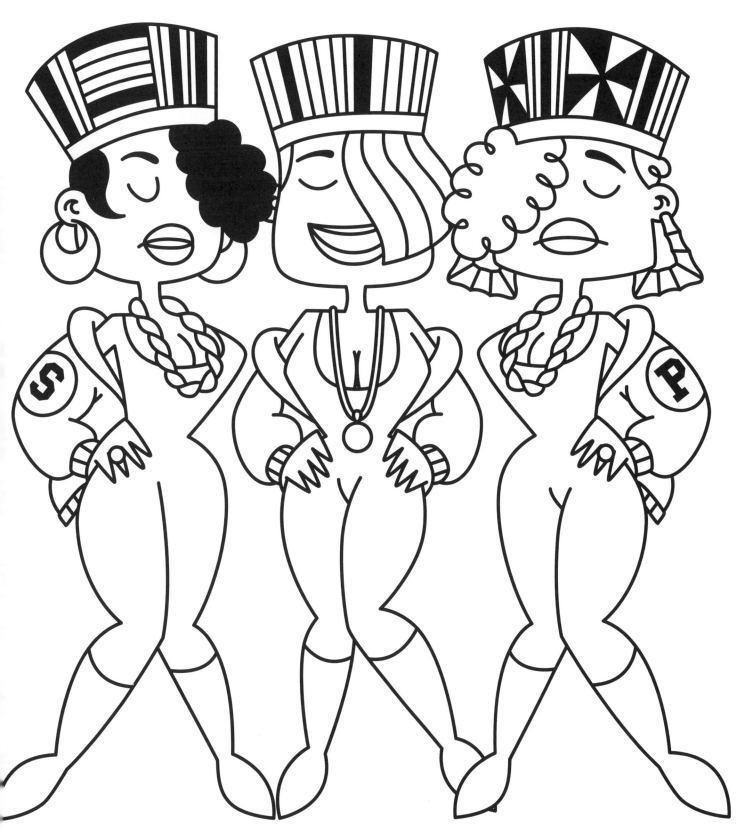

SALT, SPINDERELLA & PEPA
SALT-N-PEPA

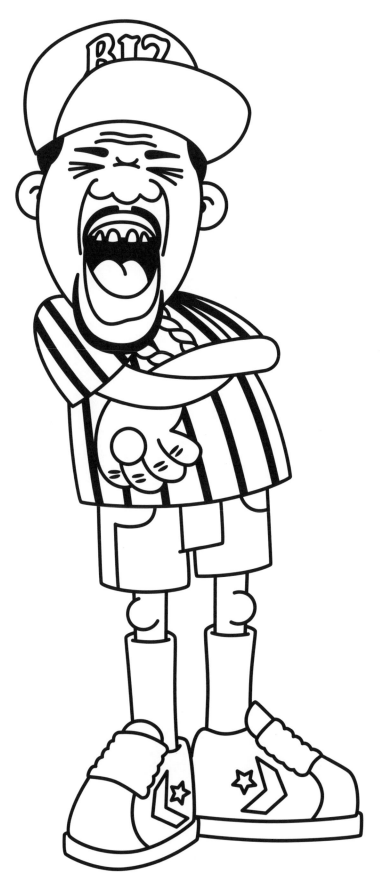

BIZ MARKIE
THE JUICE CREW

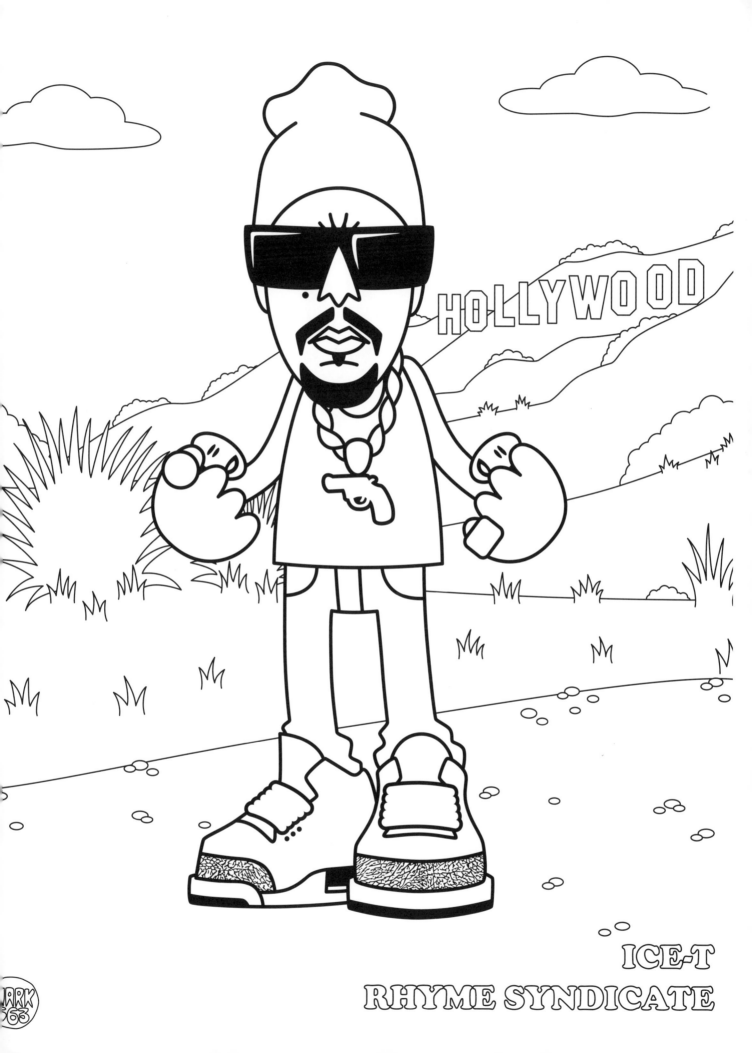

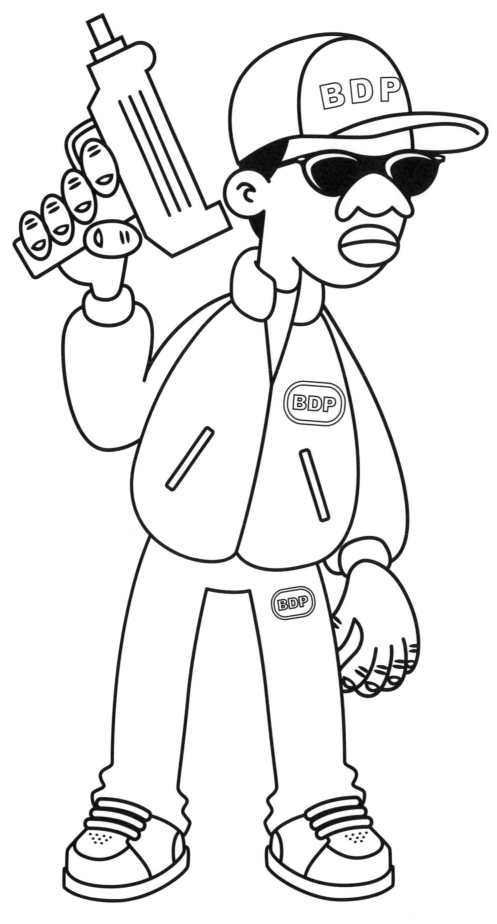

KRS-1
BOOGIE DOWN PRODUCTIONS

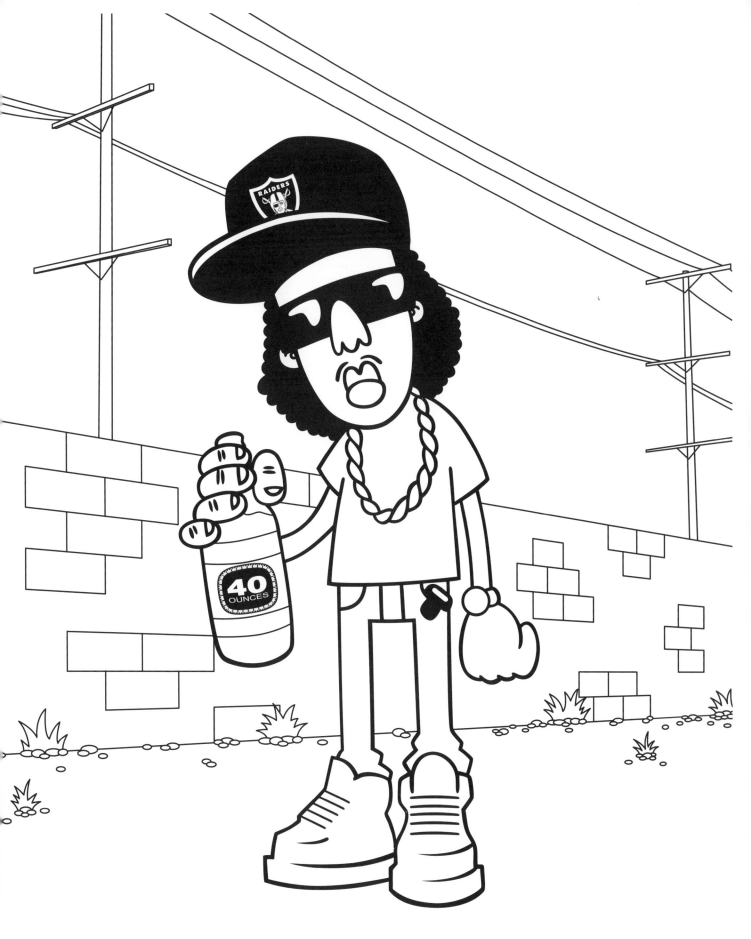

EAZY-E
N.W.A.

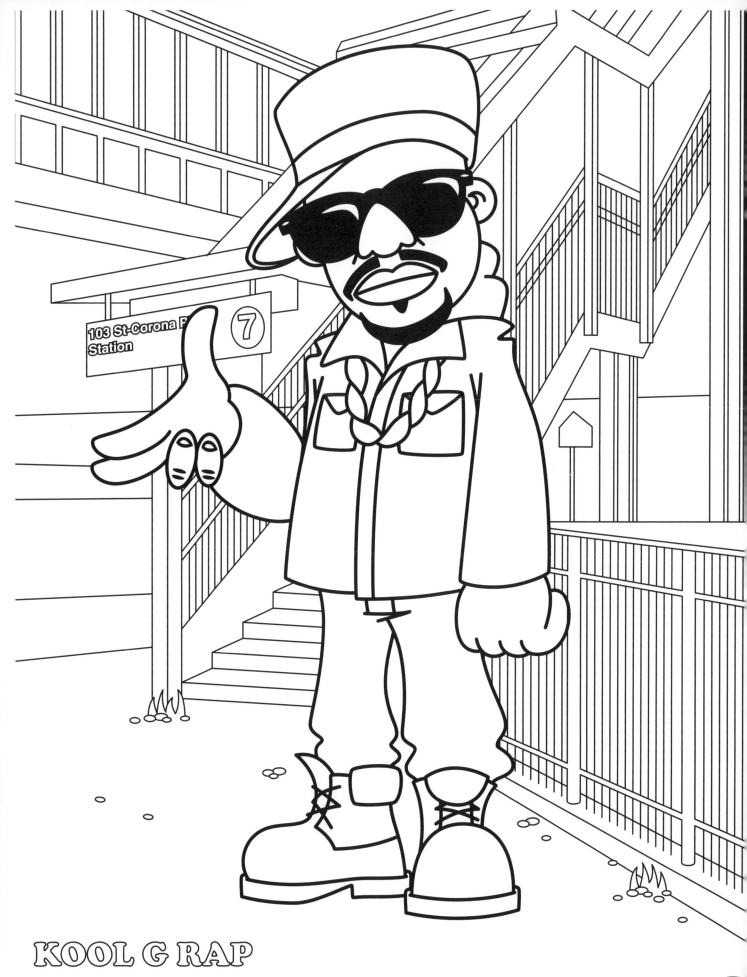

KOOL G RAP
THE JUICE CREW

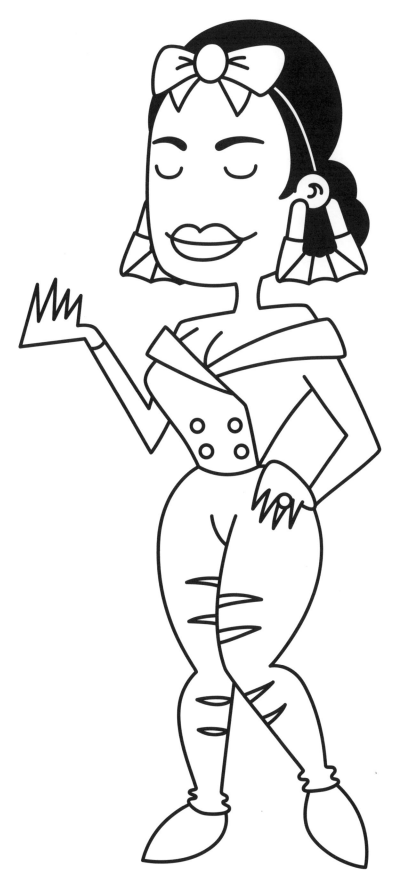

ROXANNE SHANTE
THE JUICE CREW

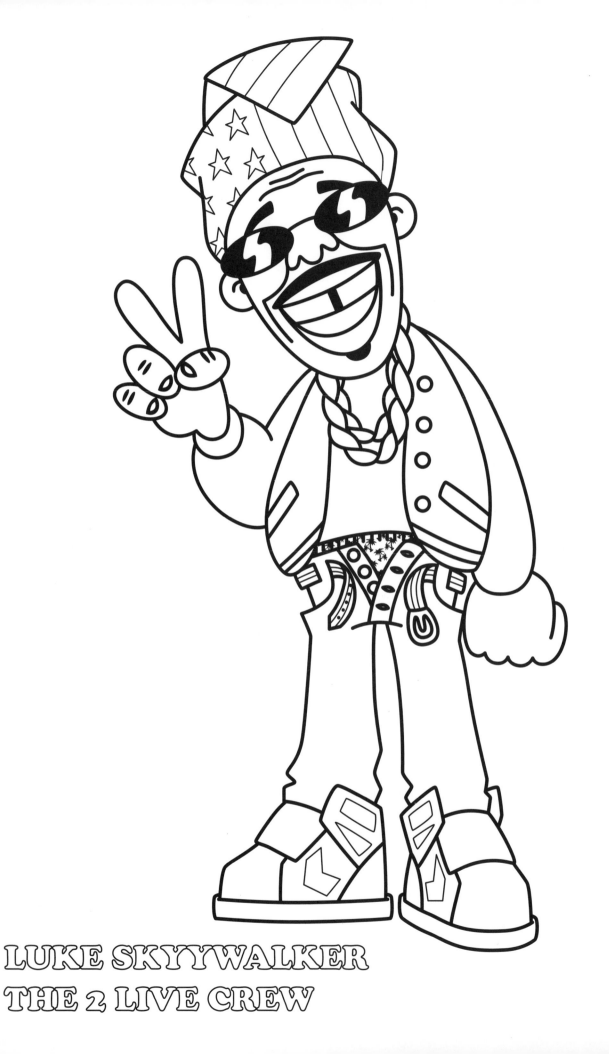

LUKE SKYYWALKER
THE 2 LIVE CREW

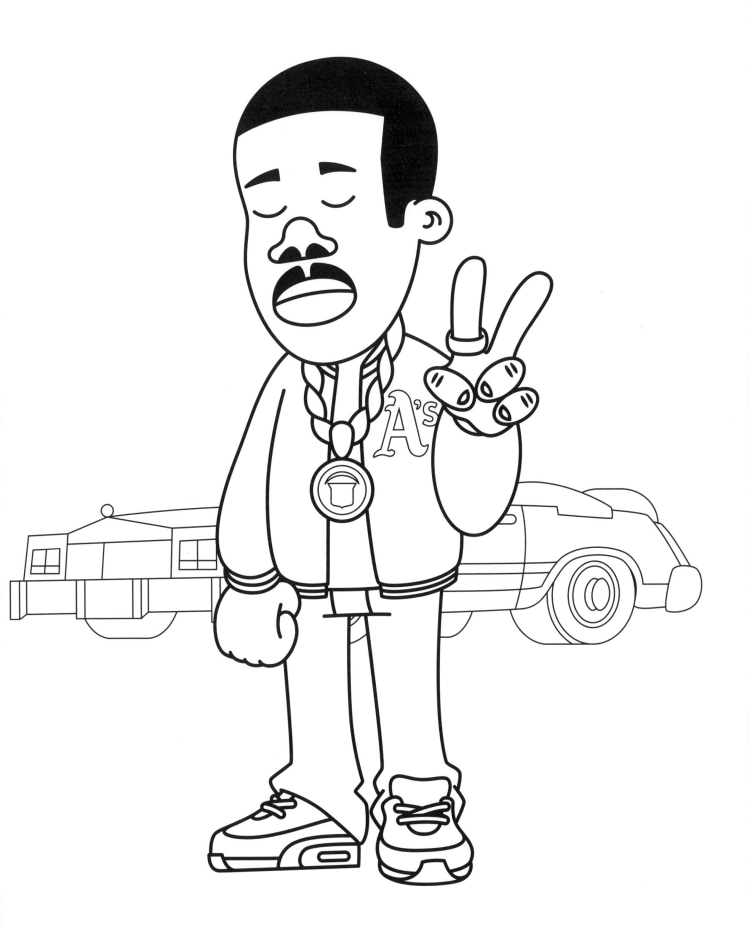

TOO $HORT

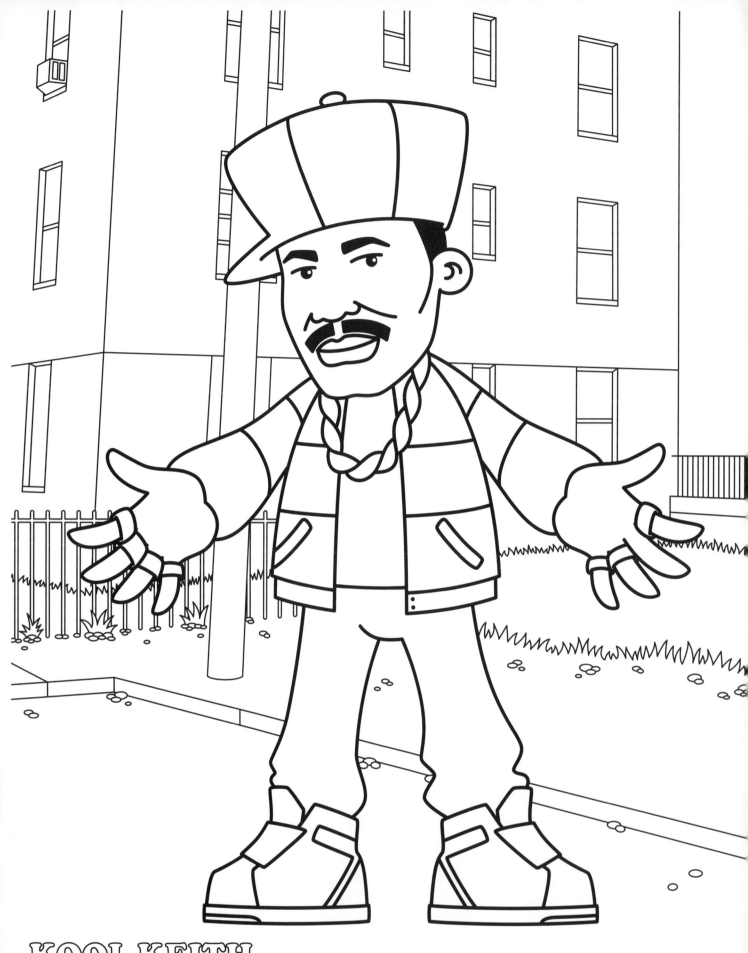

KOOL KEITH
ULTRAMAGNETIC MC'S

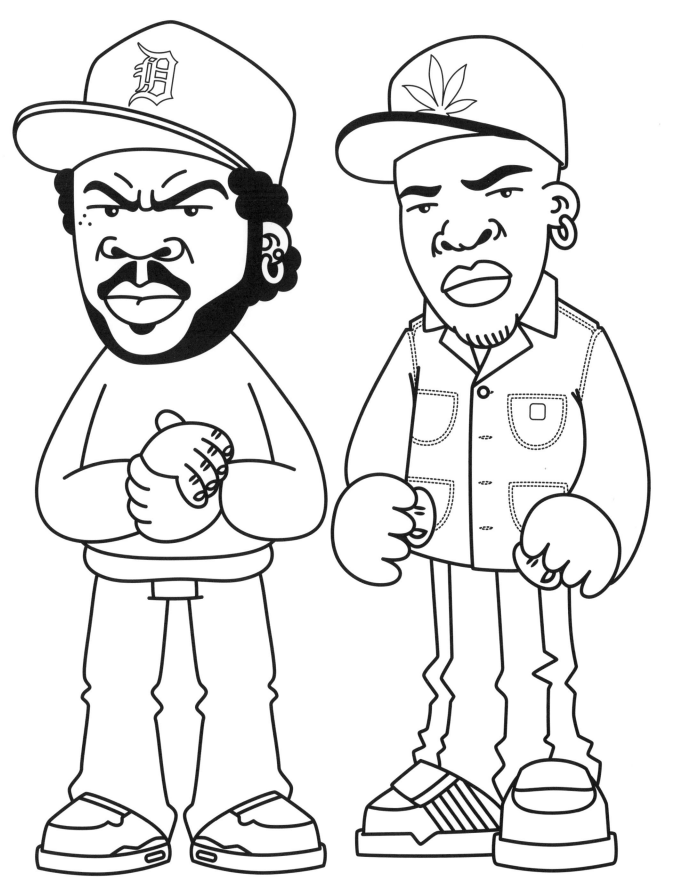

ICE CUBE & DR. DRE
N.W.A.

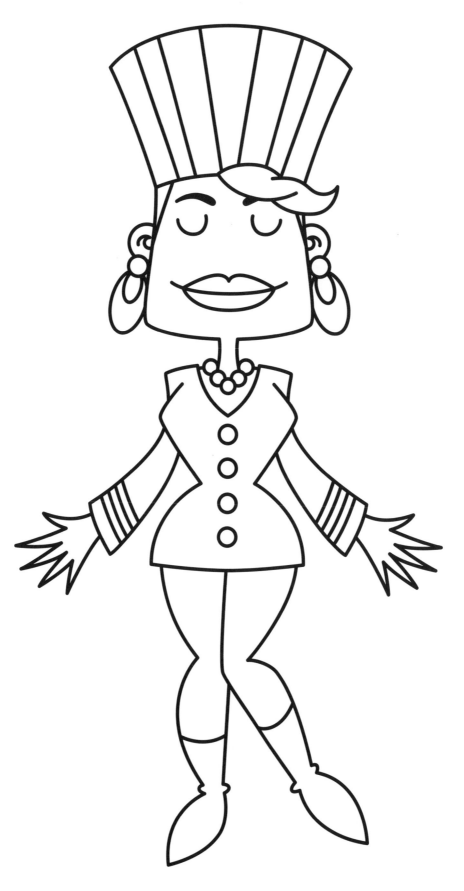

QUEEN LATIFAH
THE FLAVOR UNIT

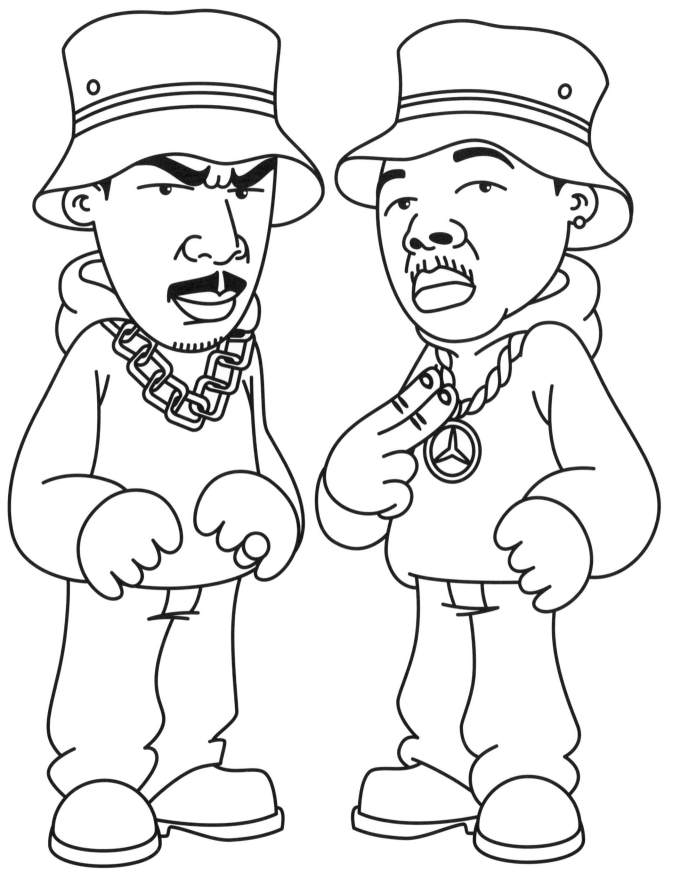

ERICK SERMON & PARRISH SMITH
EPMD

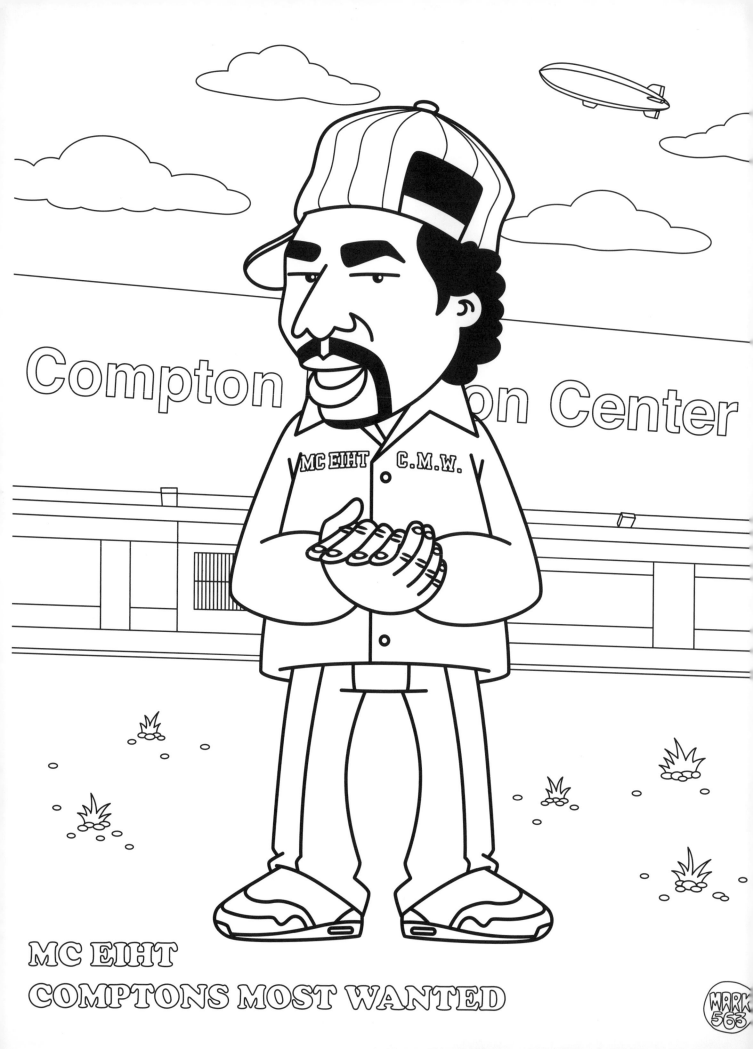

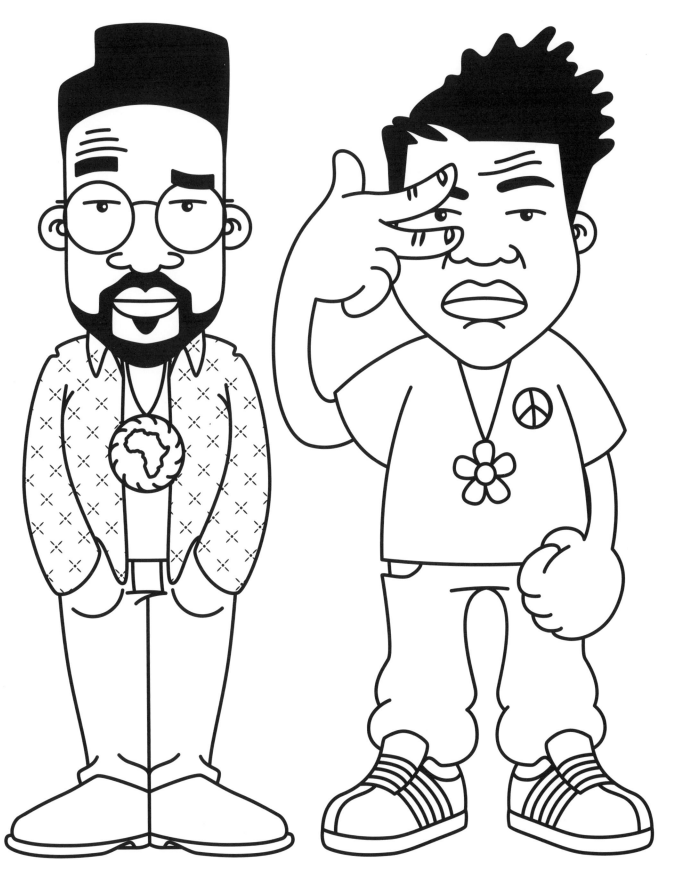

POSDNUOS & TRUGOY
DE LA SOUL

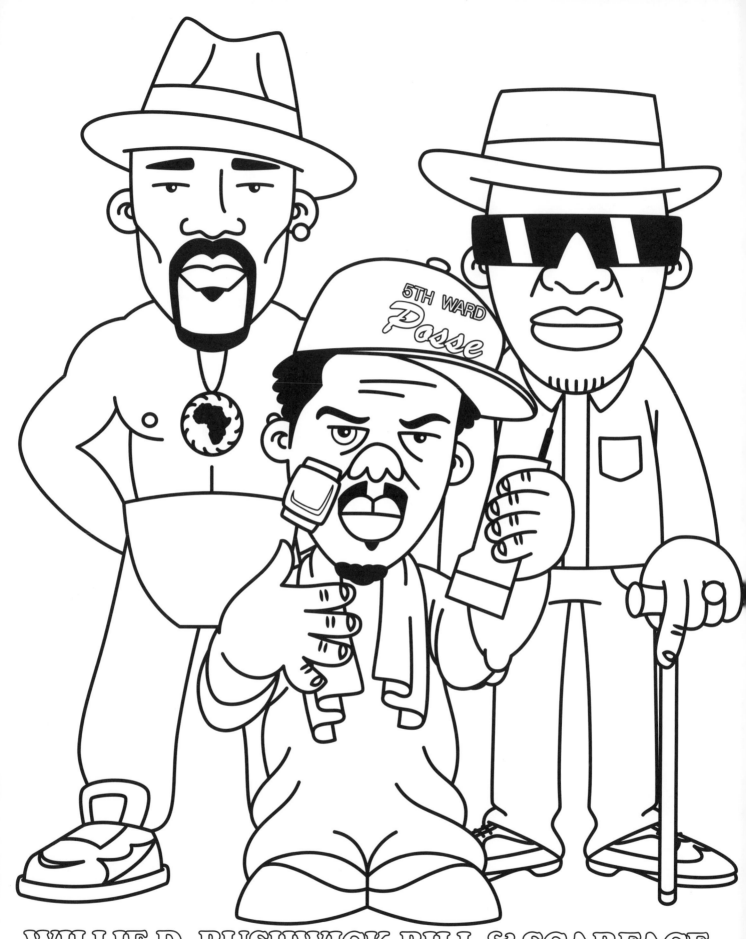

WILLIE D, BUSHWICK BILL & SCARFACE
THE GETO BOYS

MARK
563

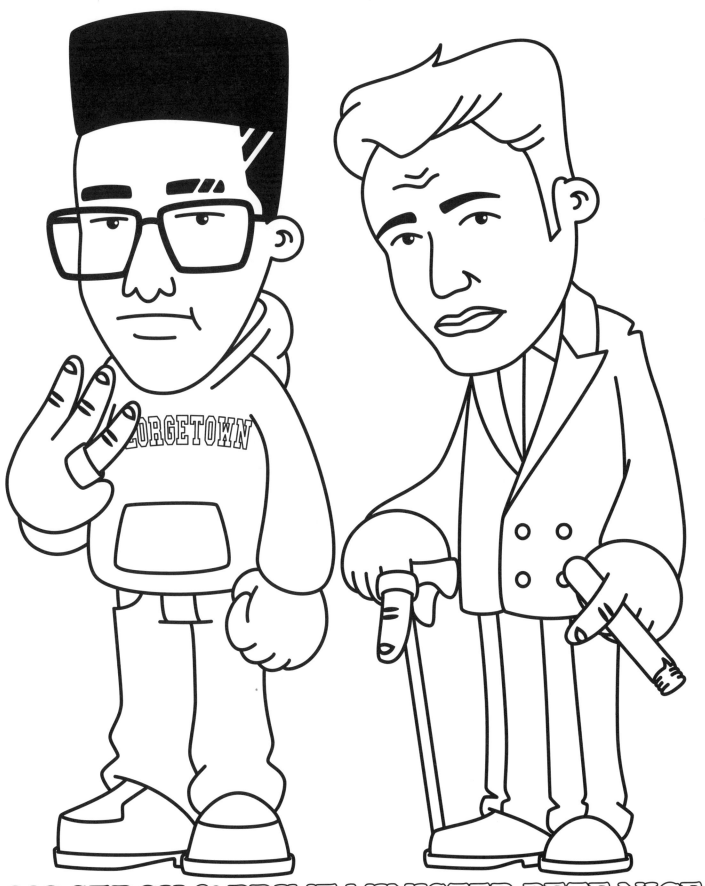

MC SERCH & PRIME MINISTER PETE NICE
THIRD BASS

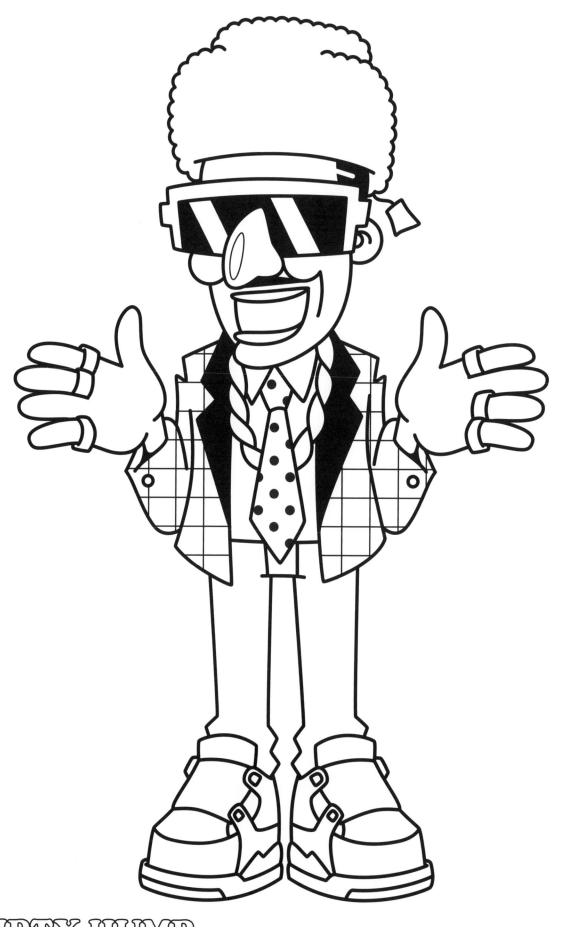

HUMPTY HUMP
DIGITAL UNDERGROUND

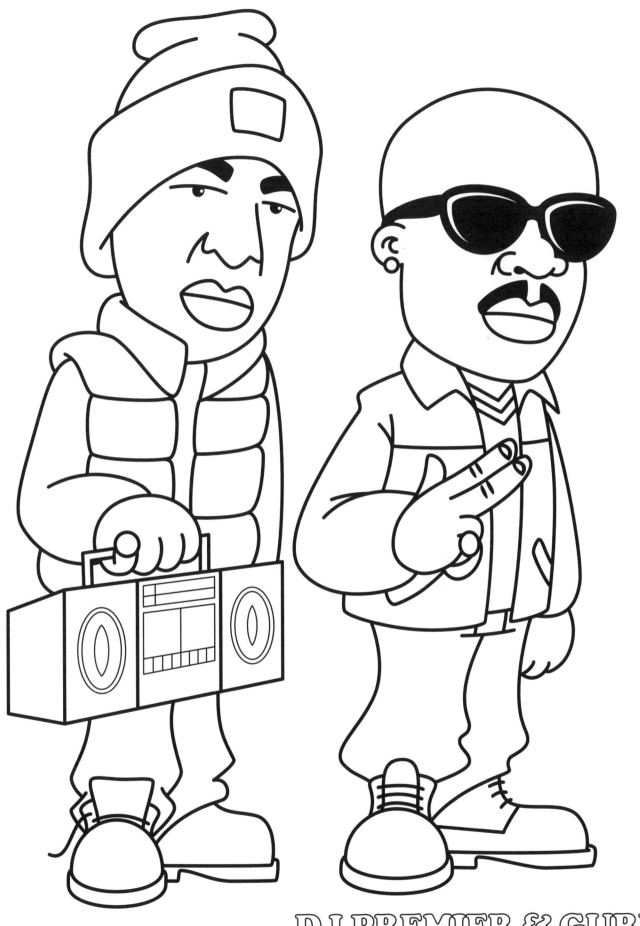

DJ PREMIER & GURU
GANG STARR

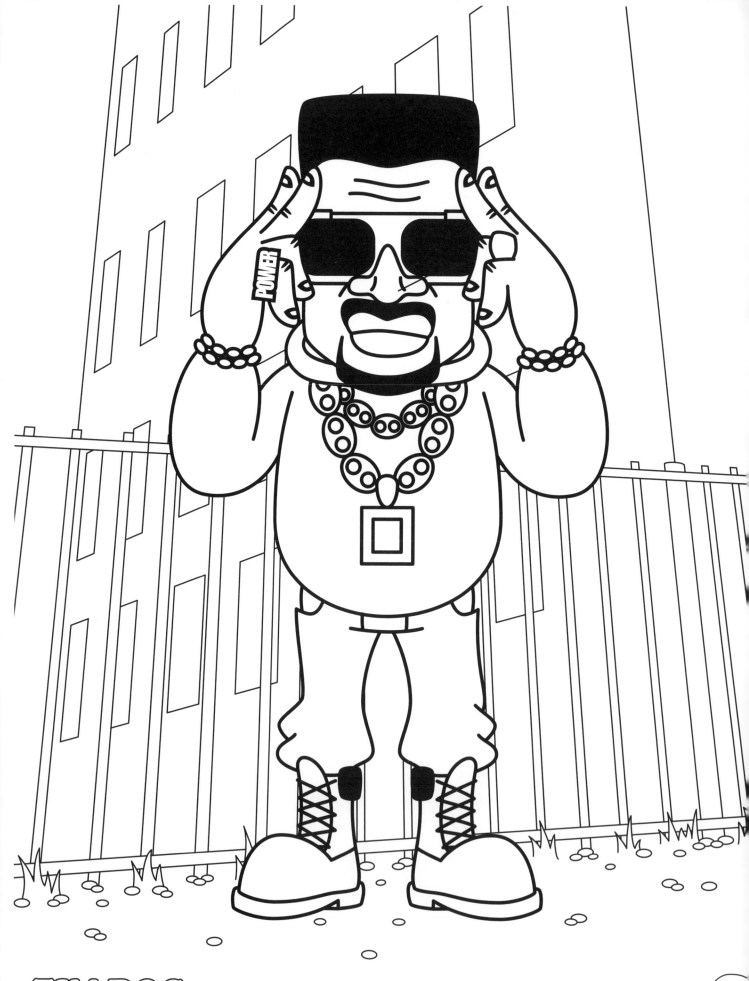

TIM DOG

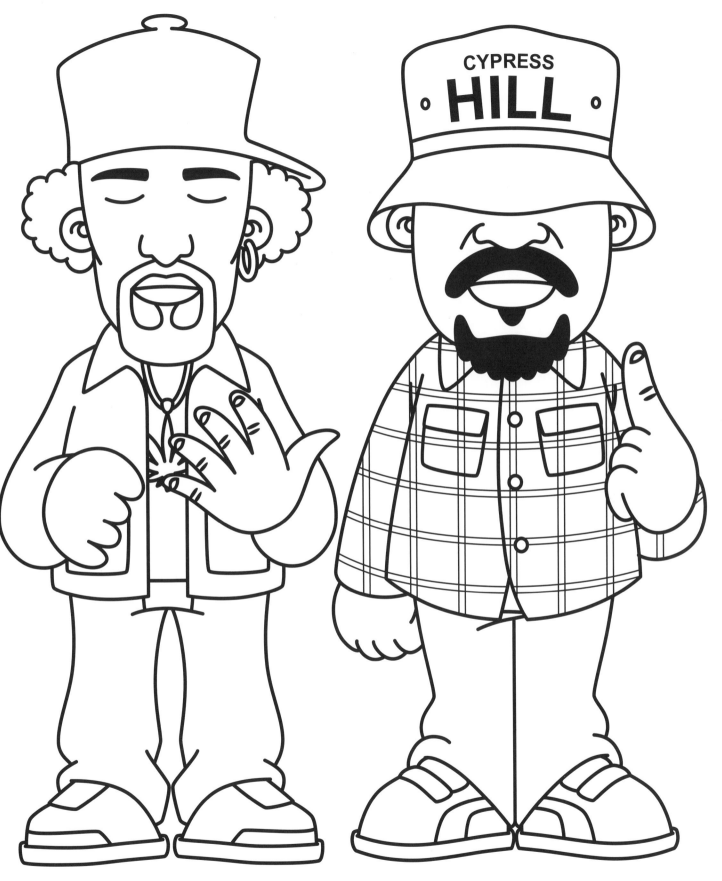

B-REAL & SEN DOG
CYPRESS HILL

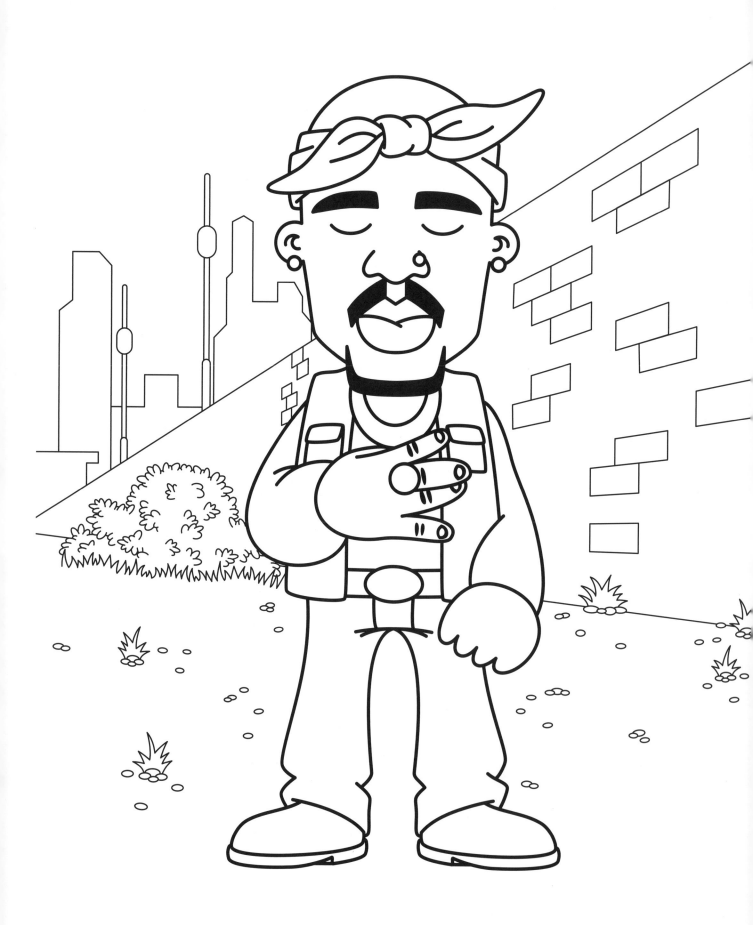

TUPAC SHAKUR / 2PAC

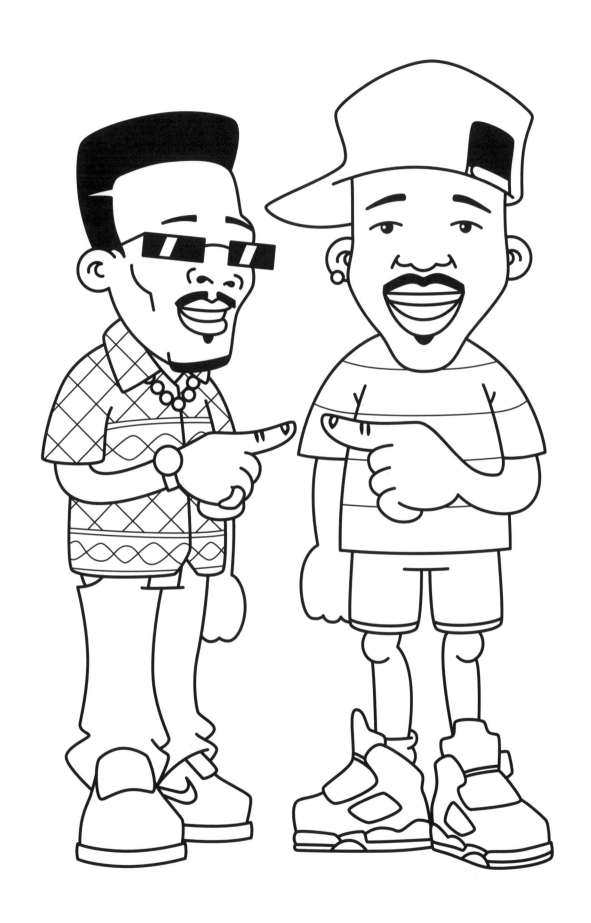

 DJ JAZZY JEFF & THE FRESH PRINCE

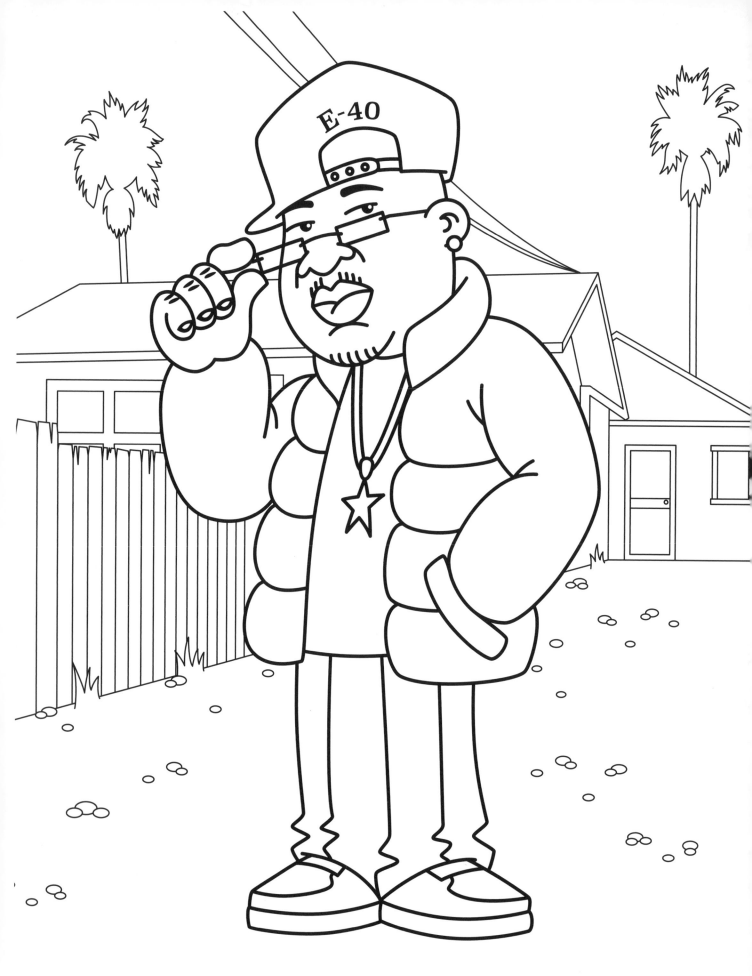

E-40

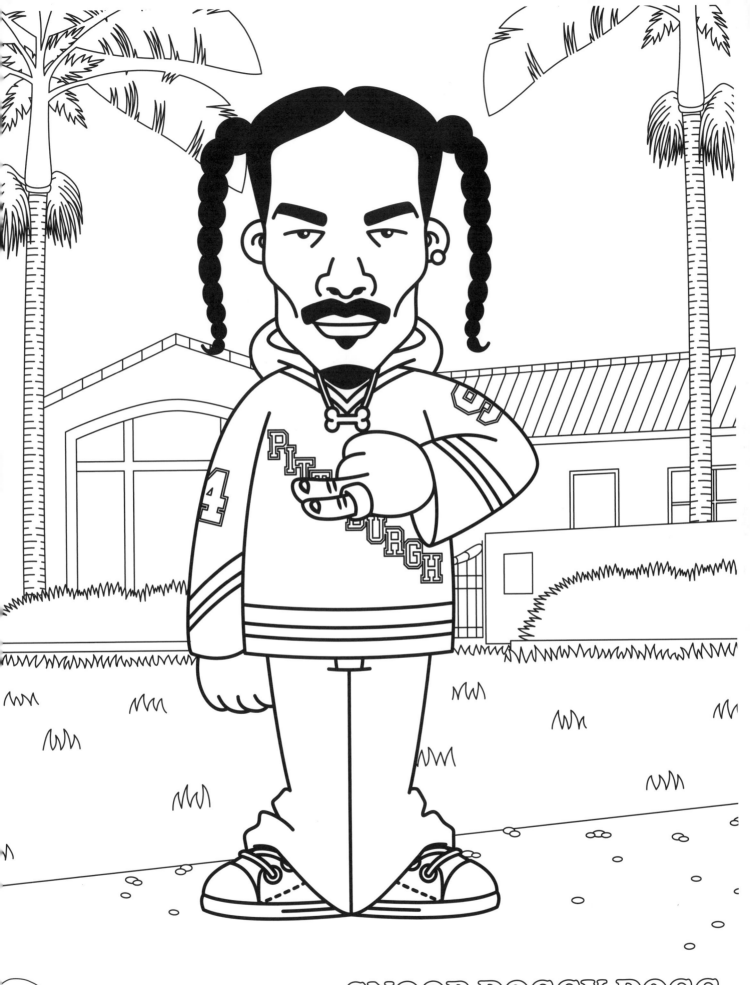

SNOOP DOGGY DOGG

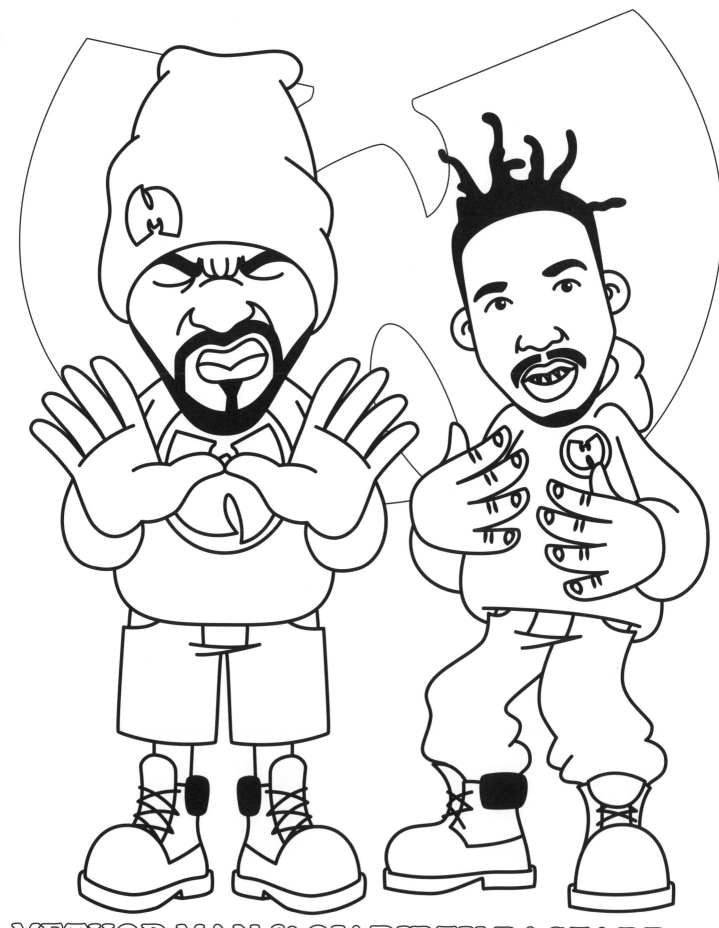

METHOD MAN & OL' DIRTY BASTARD
WU-TANG CLAN

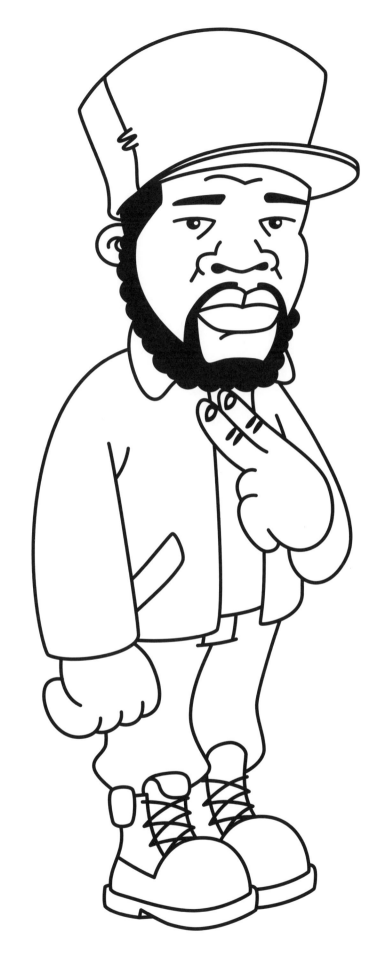

JERU THE DAMAJA

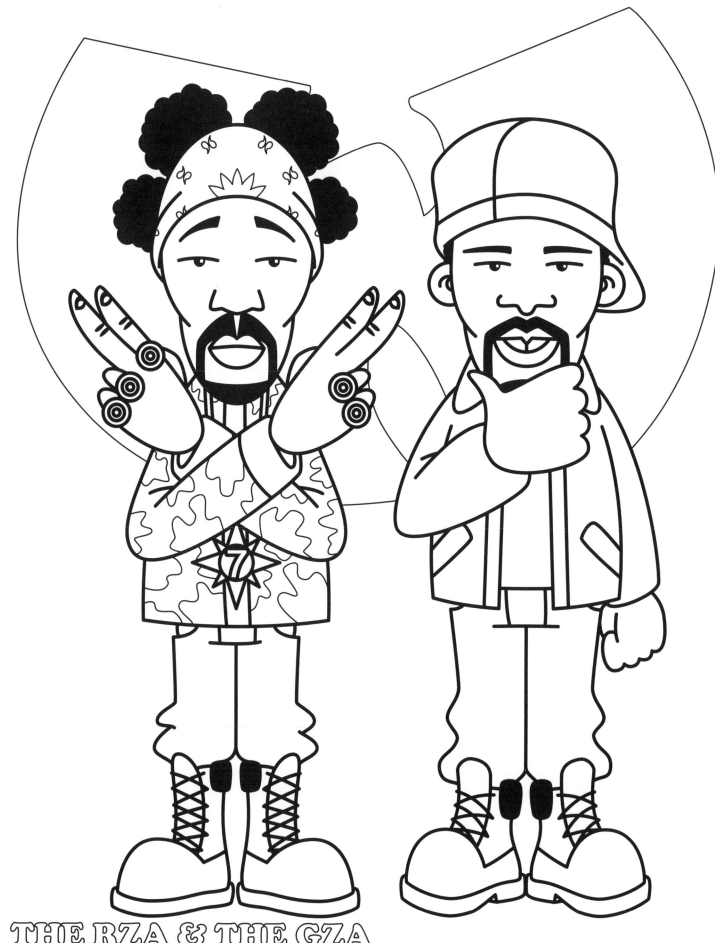

THE RZA & THE GZA
WU-TANG CLAN

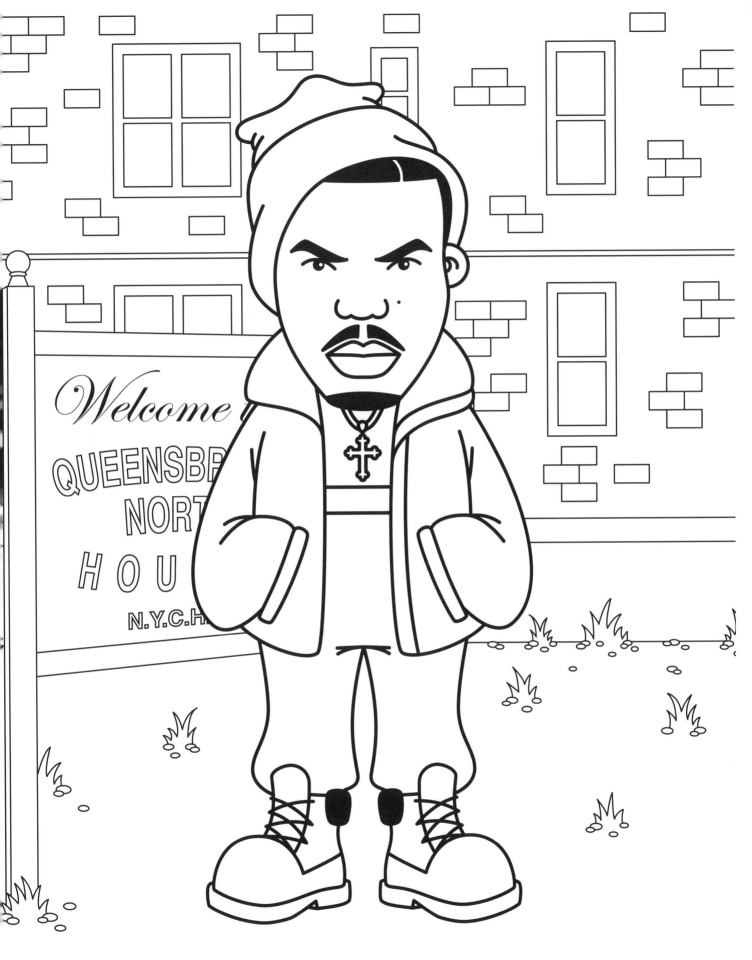

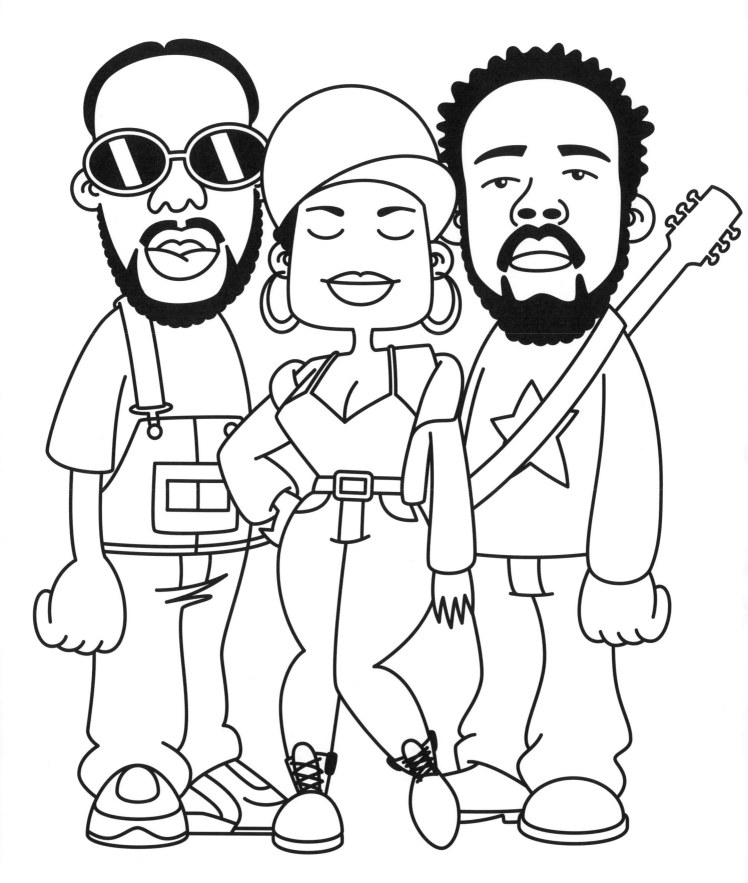

PRAS, LAURYN HILL & WYCLEF
THE FUGEES

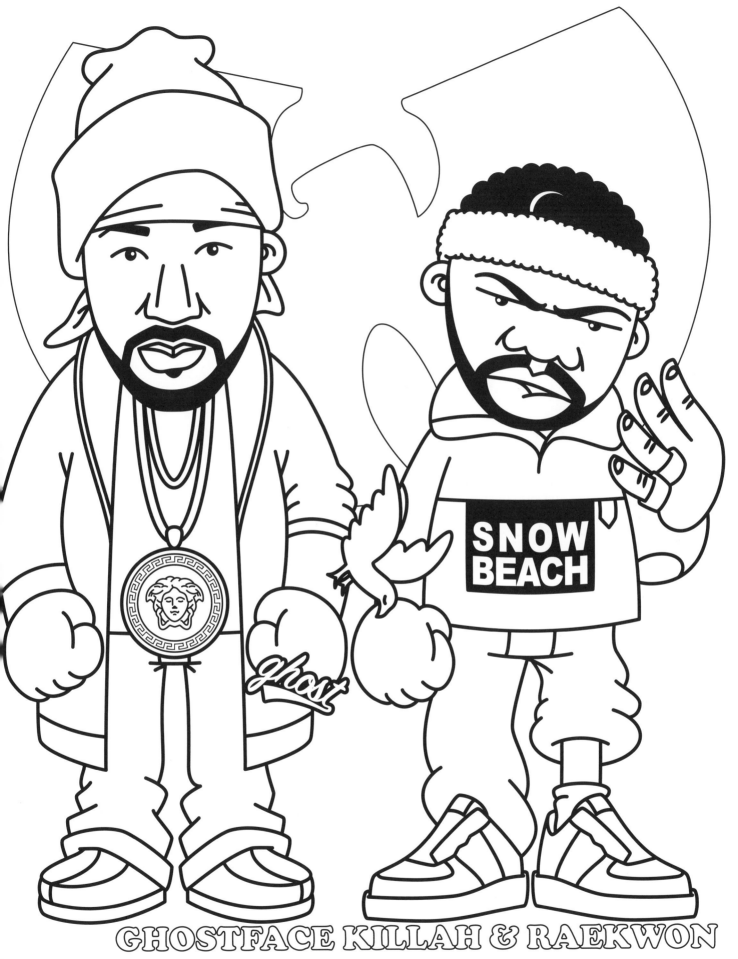

GHOSTFACE KILLAH & RAEKWON
WU-TANG CLAN

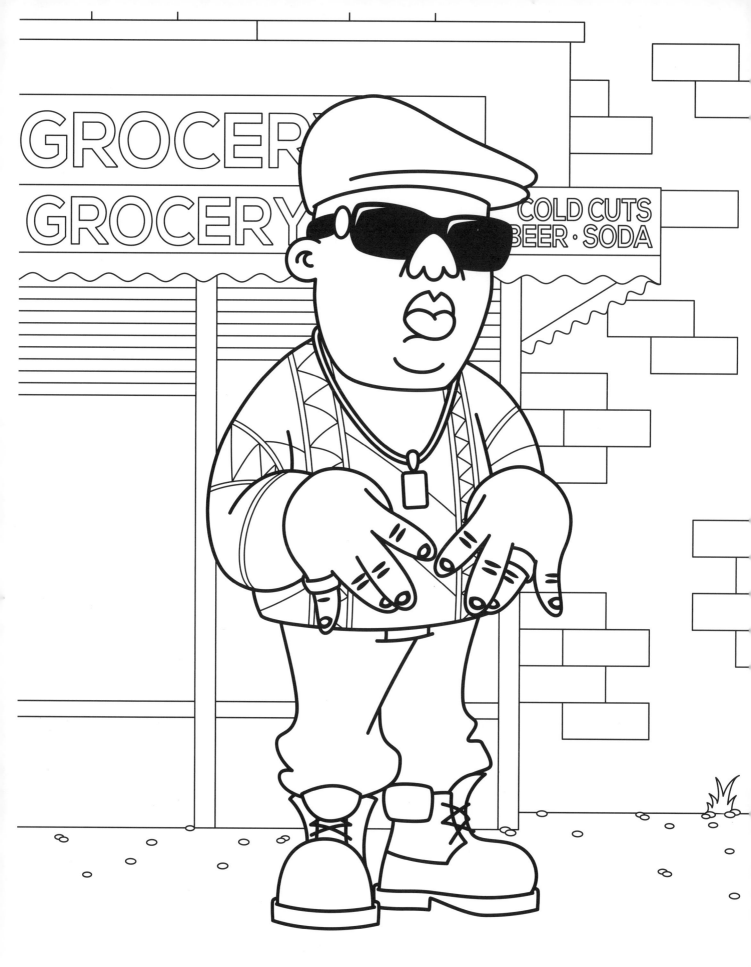

THE NOTORIOUS B.I.G.

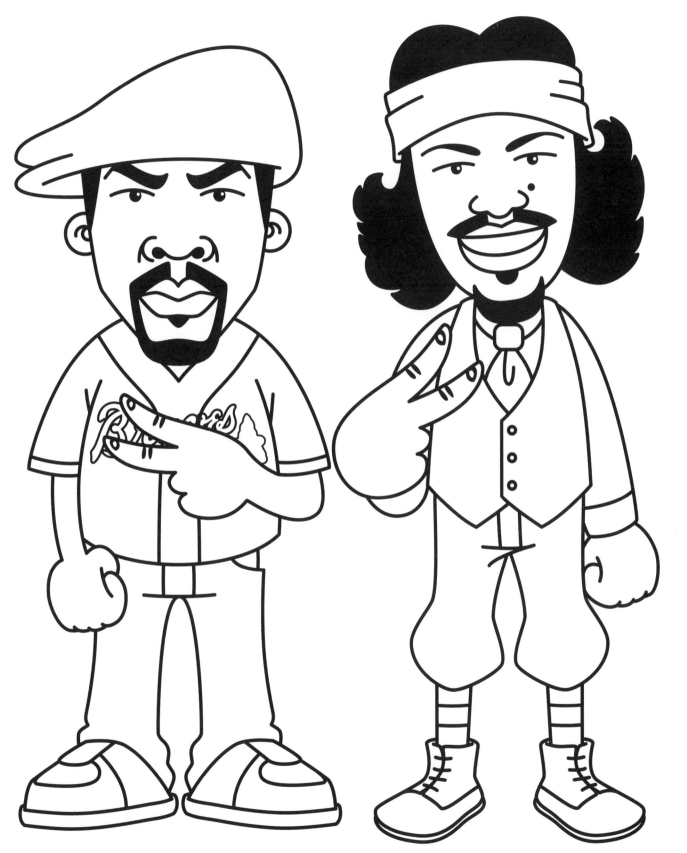

BIG BOI & ANDRE 3000
OUTKAST

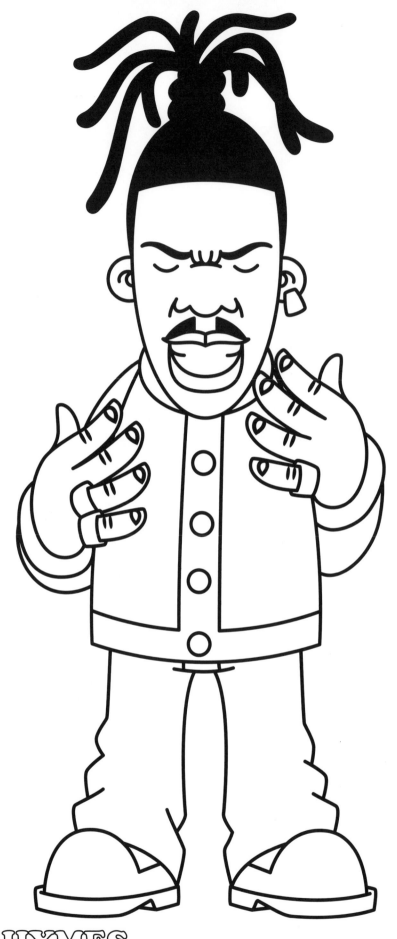

BUSTA RHYMES
LEADERS OF THE NEW SCHOOL

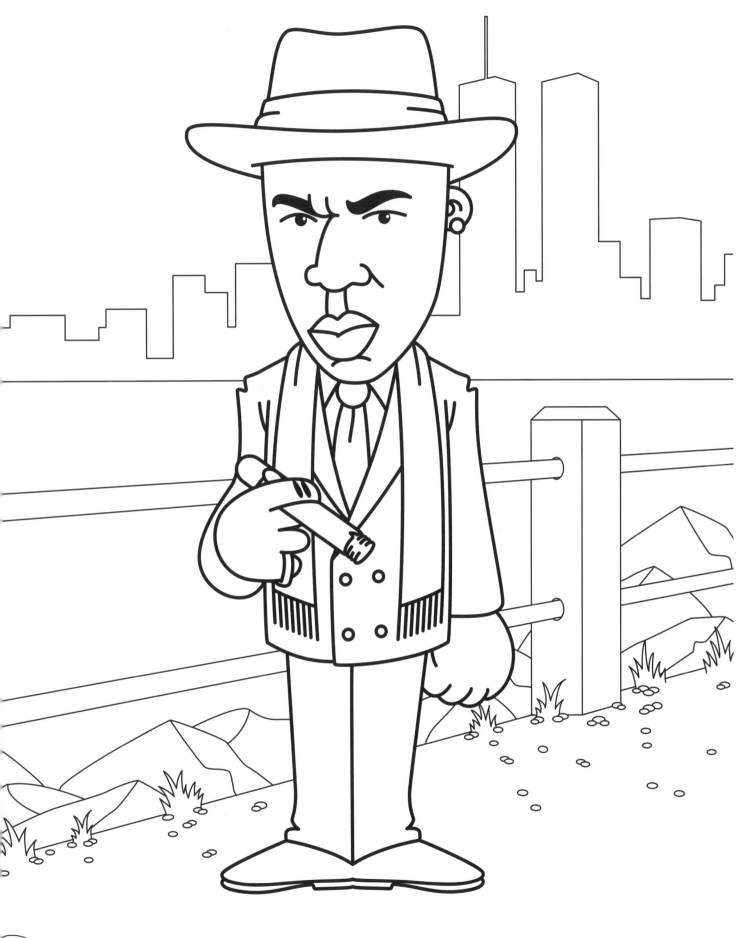

JAY-Z

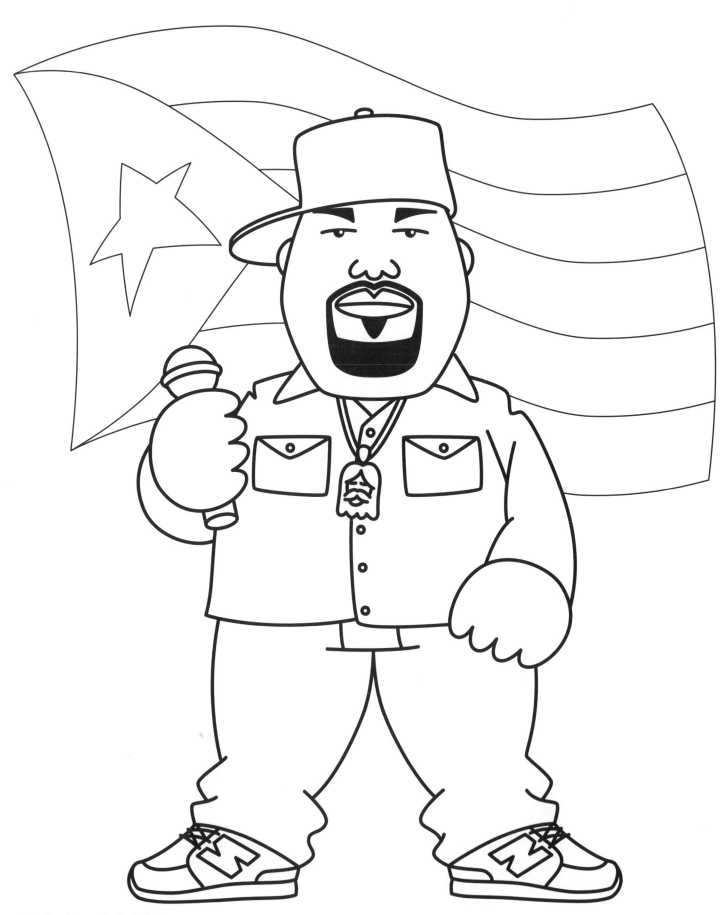

BIG PUN
TERROR SQUAD

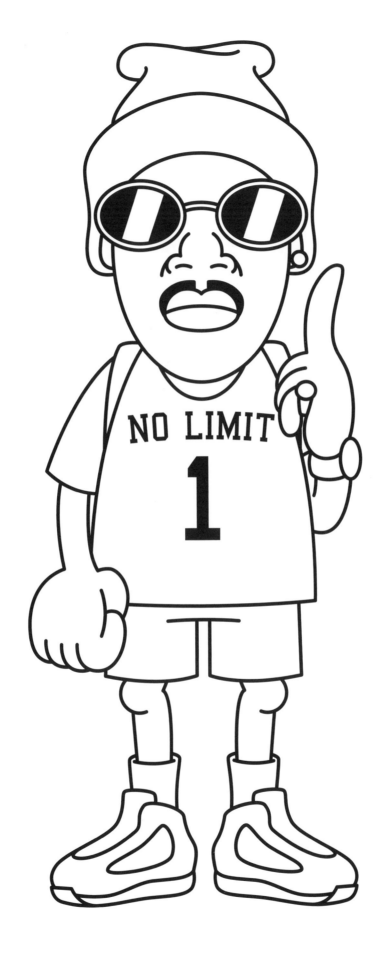

MASTER P

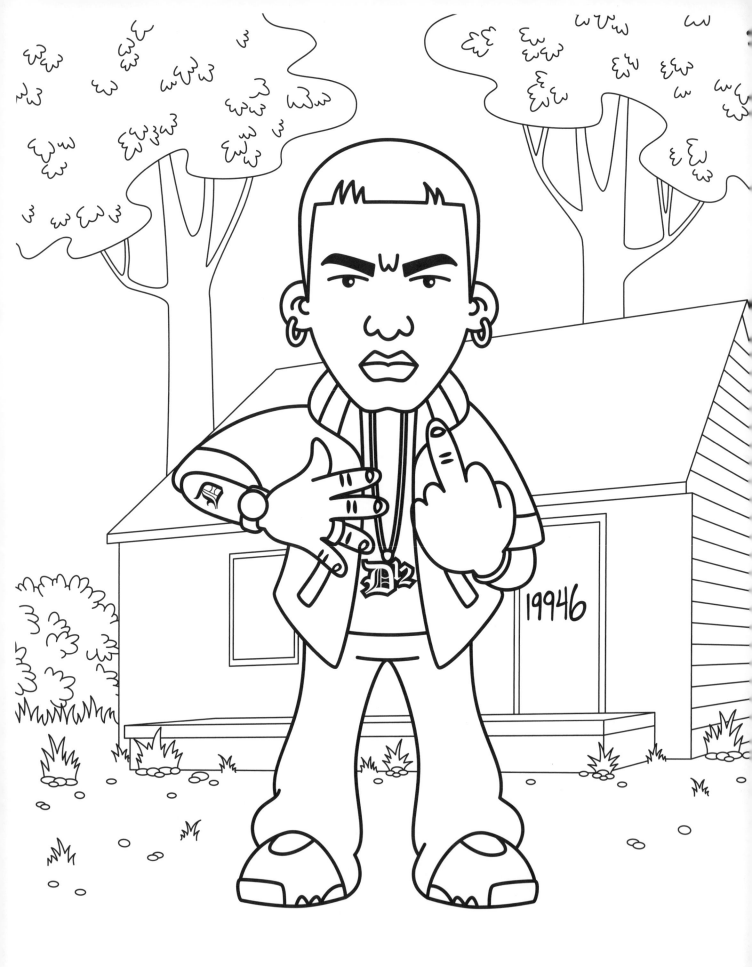

EMINEM

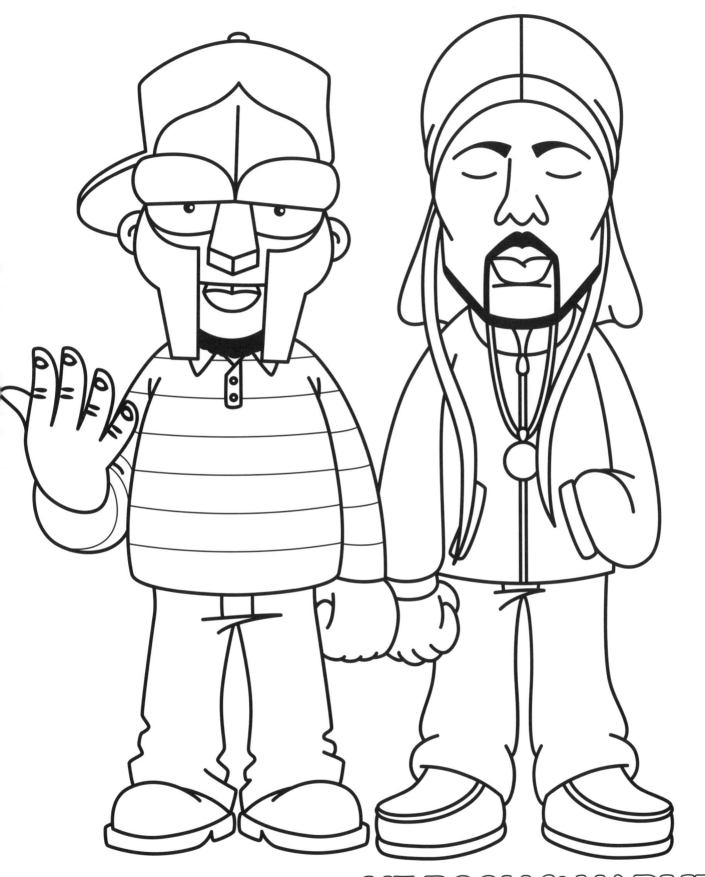

MF DOOM & MADLIB
MADVILLAIN

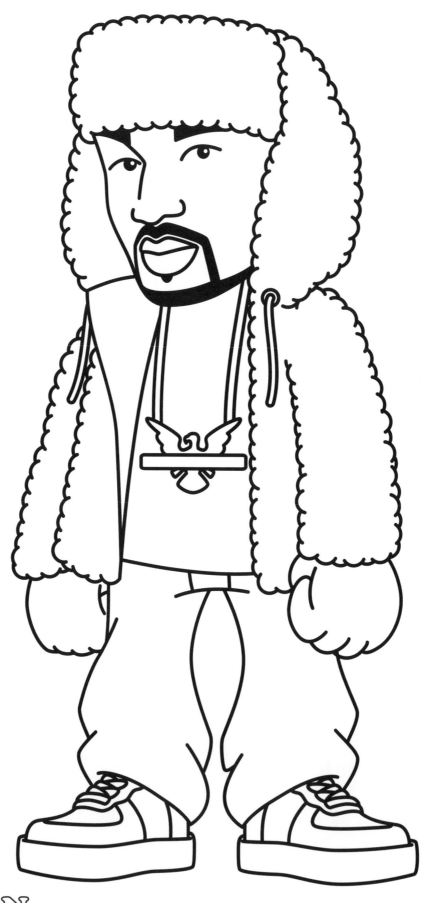

CAM'RON
DIPLOMATS

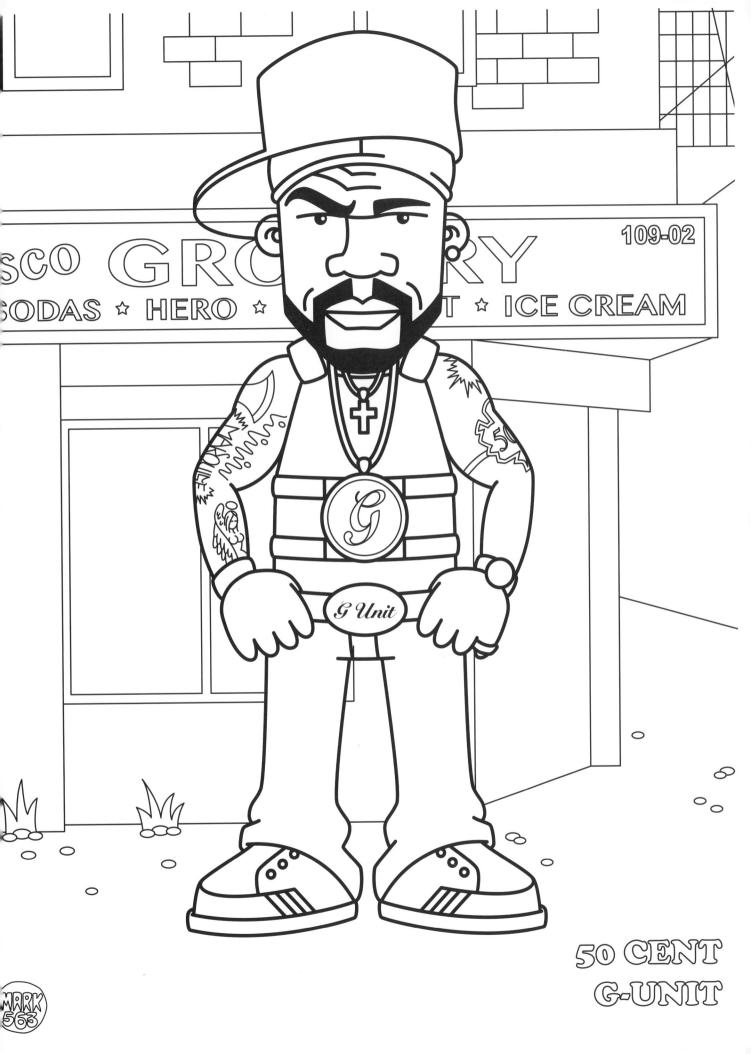

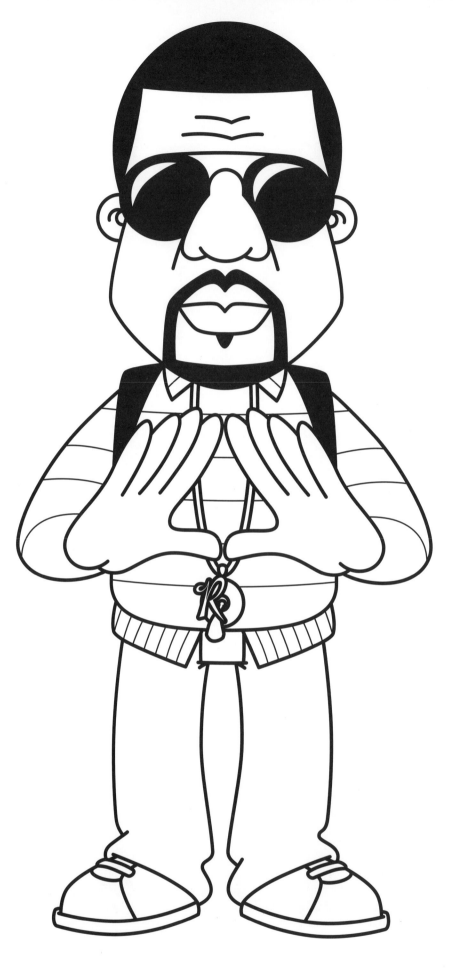

KANYE WEST

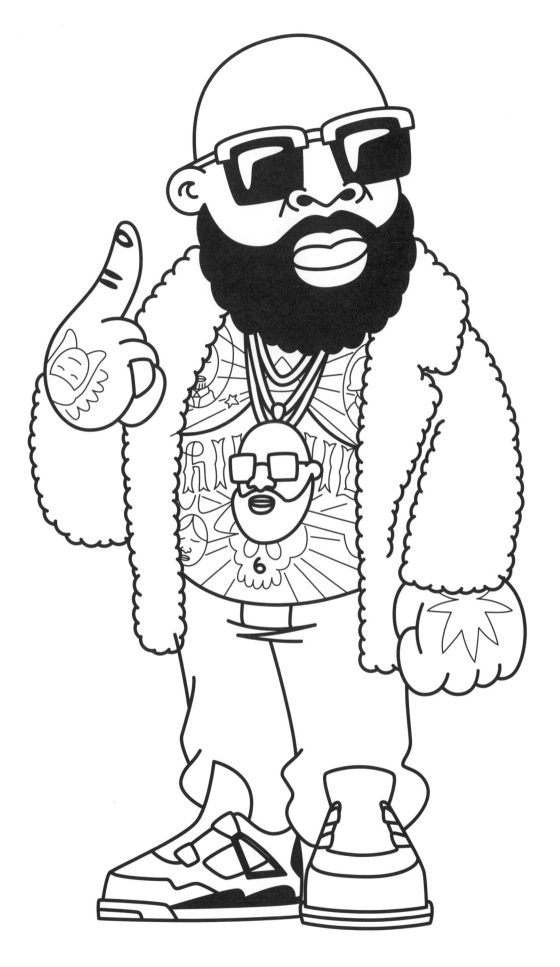

RICK ROSS

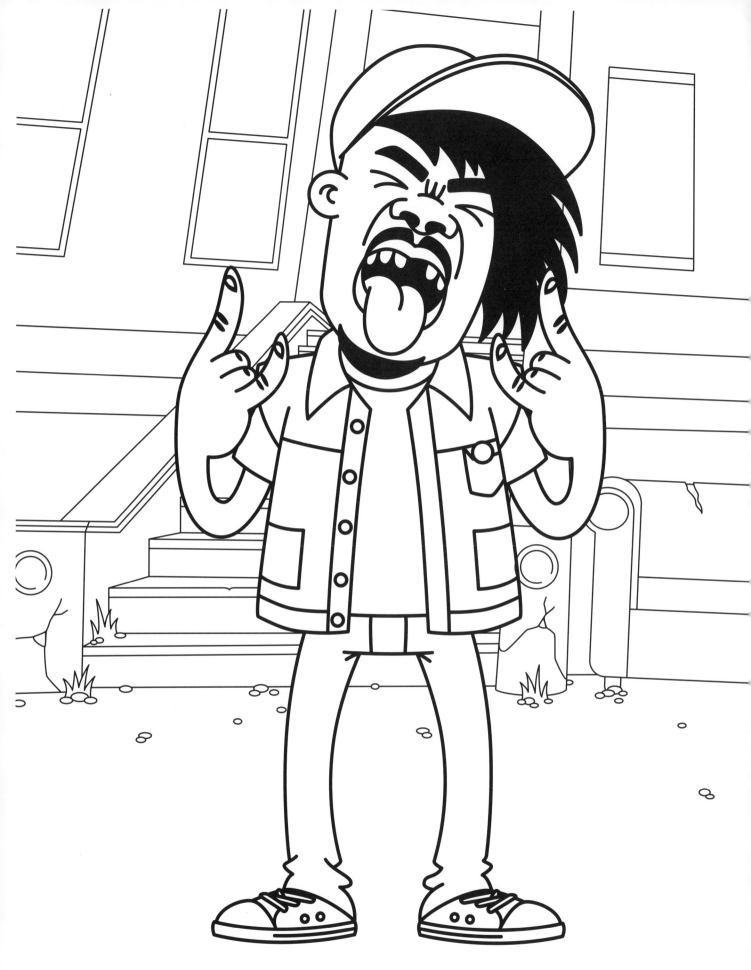

DANNY BROWN

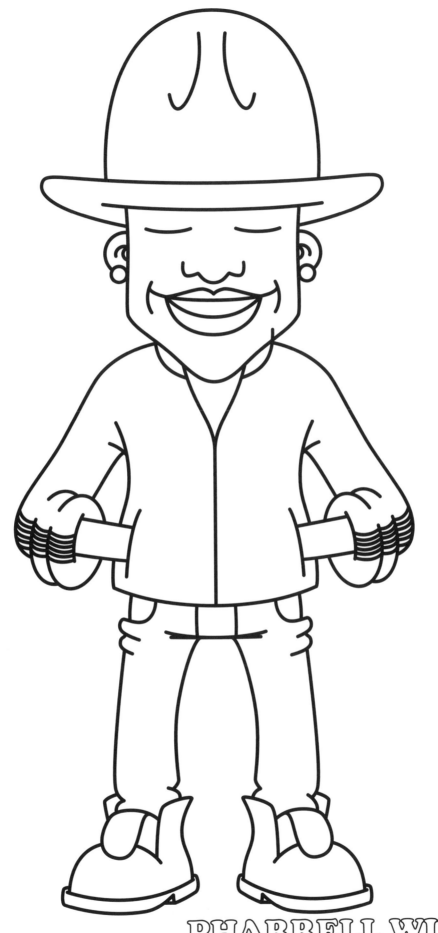

PHARRELL WILLIAMS
THE NEPTUNES

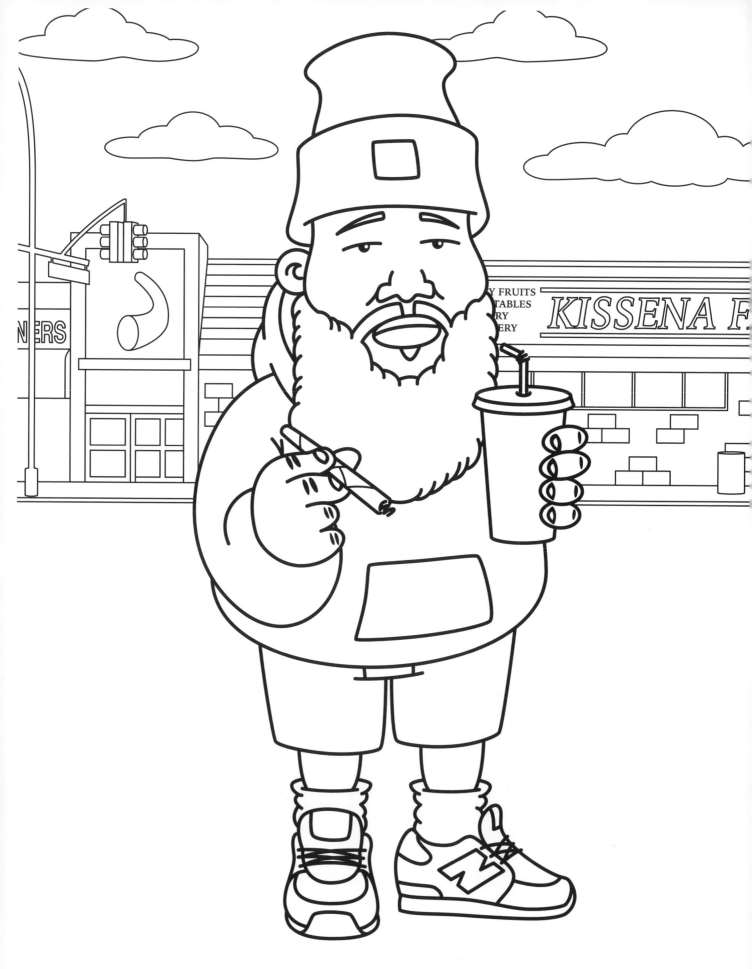

ACTION BRONSON

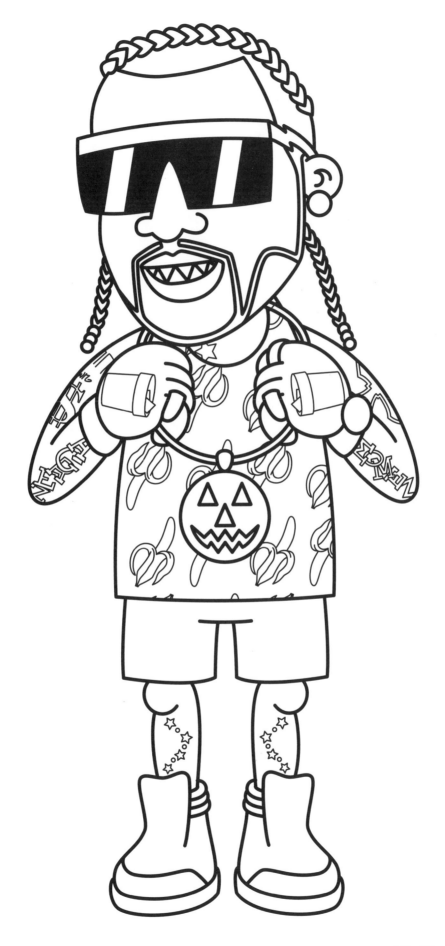

RIFF RAFF

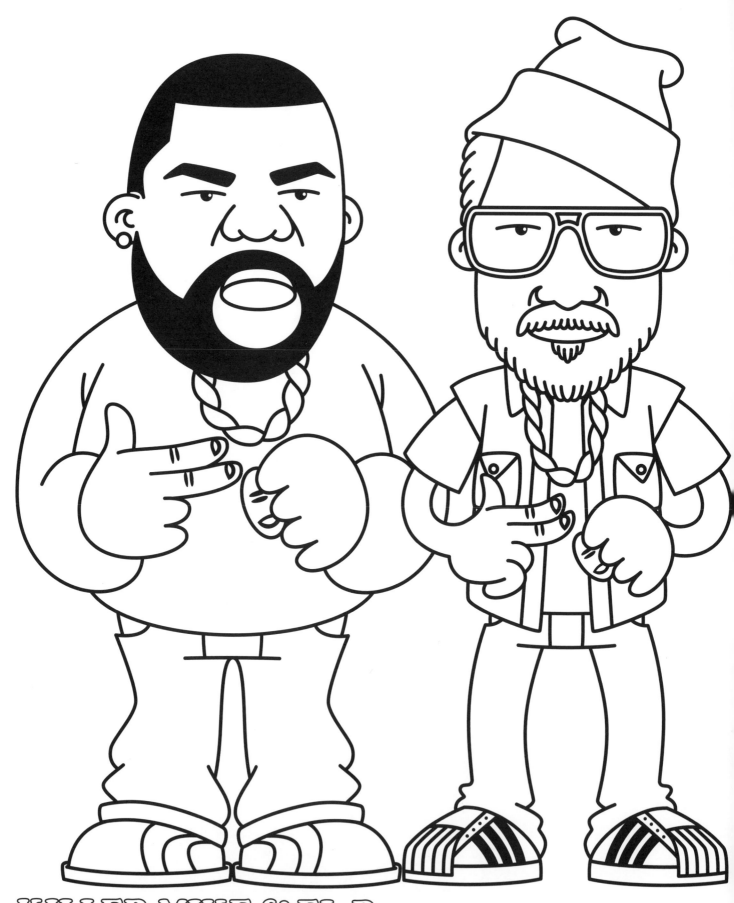

KILLER MIKE & EL-P
RUN THE JEWELS

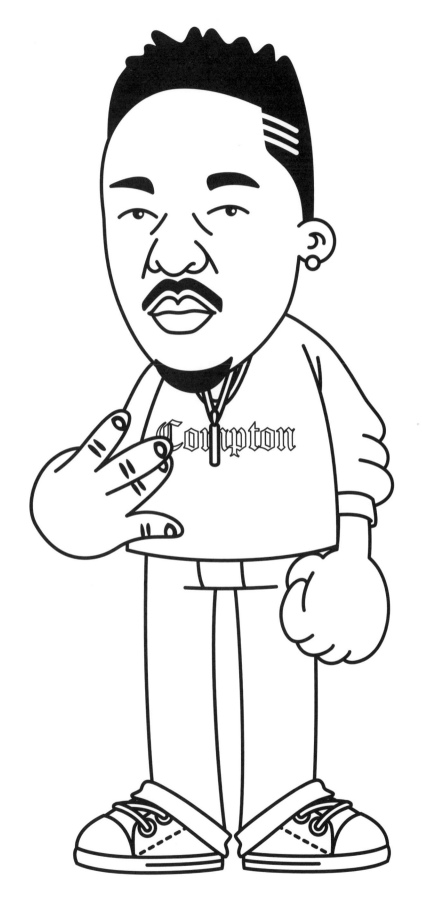

KENDRICK LAMAR

More coloring books

Graffiti Coloring Book
ISBN 978-91-85639-08-3

Graffiti Coloring Book 2
ISBN 978-91-85639-28-1

Graffiti Coloring Book 3
ISBN 978-91-85639-49-6

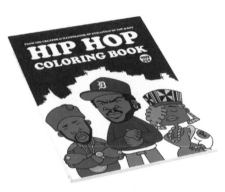

Hip Hop Coloring Book
ISBN 978-91-85639-83-0

Tattoo Activity Book
ISBN 978-91-85639-64-9

Lowrider Coloring Book
ISBN 978-91-85639-41-0

**Skateboarding
Coloring Book**
ISBN 978-91-85639-45-8

Subway Sketch Book
ISBN 978-91-85639-39-7

**Cut and Fold Subway
Sketchbook**
ISBN 978-91-85639-61-8

DOKUMENT
PRESS

www.dokument.org
info@dokument.org